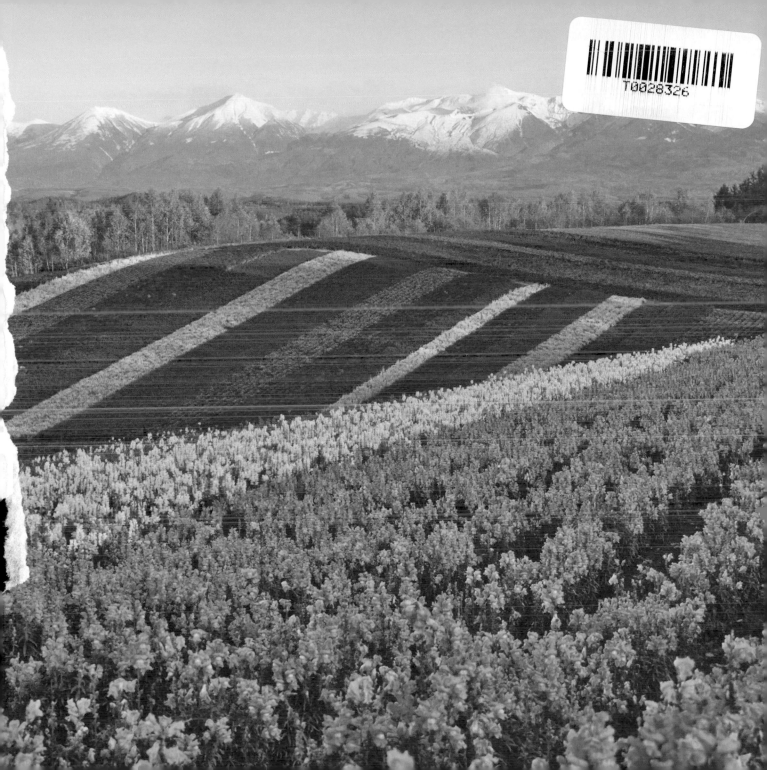

My HOKKAIDO

THE ULTIMATE GUIDE TO JAPAN'S GREAT NORTHERN ISLANDS

Aaron Jamieson

TUTTLE Publishing

Tokyo | Rutland, Vermont | Singapore

contents

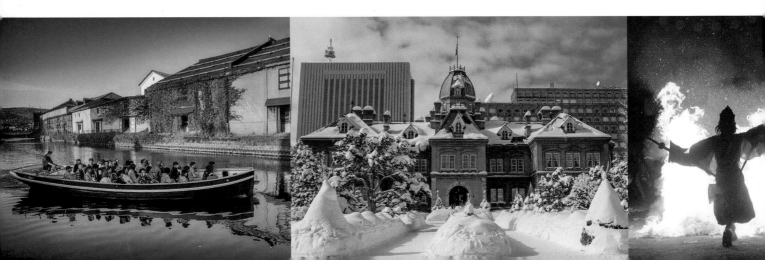

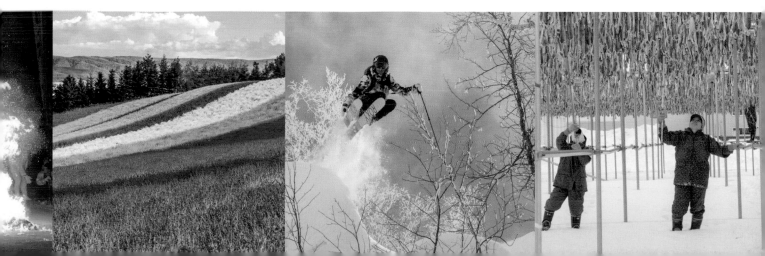

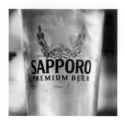

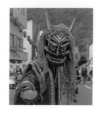

MY JOURNEY ON JAPAN'S GREAT NORTHERN ISLANDS

I still vividly remember how I felt when I first arrived in Hokkaido—an alien in a foreign place, fresh from the world of the West, transplanted to a remote frontier in far-northern Japan. These wild islands are just a stone's throw from Russia and the Korean Peninsula and yet, despite their incredible seasonal wonders and magnificent beauty, remain almost unknown to the world. Hokkaido is a volcanic exclamation mark on an island archipelago, unrivalled in cultural history and natural discoveries that are enchanting for any traveler.

I embarked on my first solo road trip to explore more of Hokkaido equipped with all the usual paraphernalia—camping gear, books of road maps, a selection of "konbini" (convenience store) food, drinks and snacks, and my ever-present camera gear. Before Google Maps, smart phones and before I'd ever received a friend request on Facebook, I

ventured out in my trusty steed—a beaten up Subaru wagon—into a world I knew nothing about, and sought to find out what was out there on these islands I'd recently decided to call home.

Fumbling my way around using Japanese paper maps that I couldn't read—getting lost most of the time—I slowly began to discover the true

intrigue of these magical islands. A wild, foreboding frontier of untamed mountains, untouched forests and frozen oceans. A seemingly ferocious environment balanced by a fragile and gentle lifecycle; as soft as a falling leaf, and as quiet as an owl. Here is a group of islands, the final clinch in a densely populated island chain, part of, yet noticeably different from, the rest of

Left Hokkaido offers a spectacular culinary twist on Japanese food, with endless new flavors and variations on traditional Japanese cooking bred in the northern frontier.

Top left Sapporo Beer, Japan's oldest brand and a national icon from the islands of Hokkaido.

Top middle The Noboribetsu Hell Festival is held annually in August, marking the time of year when the gates of Hell Valley (Jigokudani) open, and Enma, the King of Hell, emerges to walk the streets of the city with his demons.

Top right Hokkaido is well known for its abundance of volcanic hot springs, making it a destination of relaxation and rejuvenation.

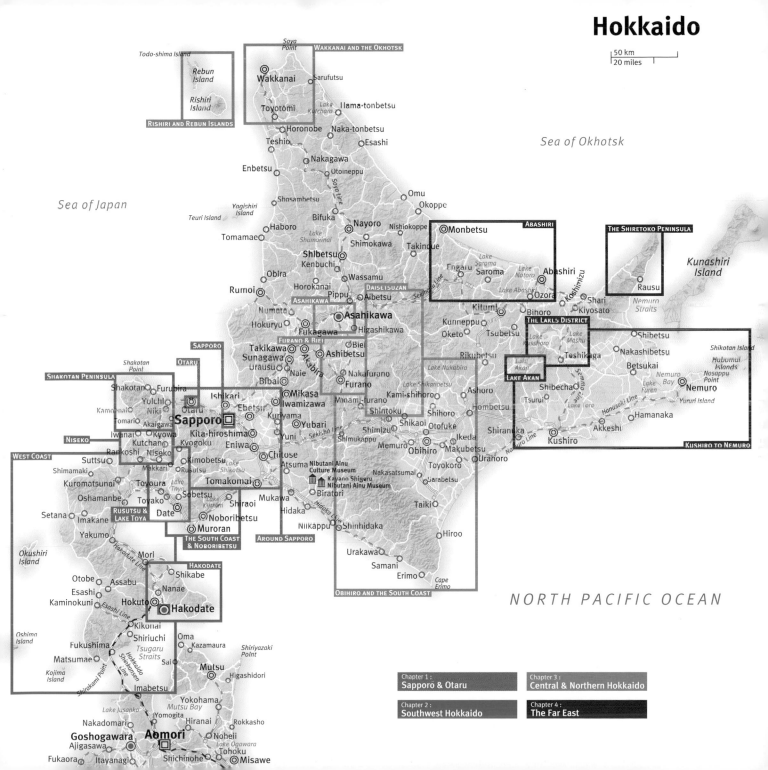

Cold and fertile waters surrounding Hokkaido make it a mecca for fresh and delicious seafood, well known as some of Japan's best.

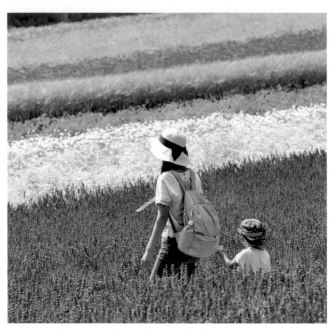

Wandering through the vibrant flower fields of Furano. Peak lavender season is usually during July with a wide variety of blooms continuing all summer.

the nation—A resonating statement of independence from the bustling megalopolises of one of the world's largest economies.

Here in Hokkaido life is different. Connected but disconnected.

It is connected to the unique nature and seasons of this hidden pocket of Asia and is part of Japan, adopting the customs and culture of the proud nation that has defined life in this region of the world for thousands of years. Yet until very recently—arguably due to its inhospitable nature—the Japanese paid little mind to the cold northern islands, leaving Hokkaido as

the native homeland of the indigenous Ainu people. In the last 150 years Japan has rapidly moved to inhabit and develop Hokkaido, the initial catalyst partly to prevent likely Russian advancements or claim to the islands. For that reason it doesn't have a long history as Japanese territory and therefore looks and feels different—disconnected—from the rest of the country.

In a sense, this disconnect means Hokkaido is still somewhat of a northern mystery, largely undiscovered and therefore retaining a distinct air of intrigue for foreigners and even people from other parts of Japan. The islands

are still wild, still free, and with a map and a hint of adventure in your spirit, there is a new world waiting to be discovered by intrepid travelers.

Hokkaido is a road tripper's dream, and for me there's nothing better than loading a van with gear and setting off on a "choose-your-own-adventure" style expedition with a rough destination in mind, but everything in between yet to be discovered. With every season so distinctly different, revisiting favorite sites always gives a new perspective and new understanding of just how diverse the islands are. For this reason my exploration is never ending and my

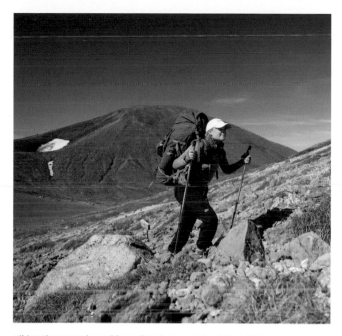
Hiking the rugged, smoking volcanic mountain of Asahidake, Hokkaido's highest peak at 7,516 ft (2,291 m).

Sapporo beer, available everywhere and an iconic staple beverage of the Islands.

greatest joys are sharing my discoveries with friends and clients—and enjoying them all over again myself.

After what was supposed to be a mere holiday, more than a decade later I'm still here. Still adventuring, discovering and finding day after day that the more I come to understand, the more I realize that there is so much more to learn.

I love it here—truly love it. I love the wild nature of the islands, the severity of life lived in sync with the seasons and at the mercy of the weather. To live in Hokkaido you need to embrace the inherent nature of the land. There is no doing things your way—the weather defines the way you live and accepting the flow of the seasons is the only way to live in harmony with Mother Nature. In winter it's cold, constantly snowing and entirely white. In summer it's alive, vibrant and energized—maximizing every moment of life. The resilient, pioneering inhabitants of Hokkaido (affectionately known as "Dosanko") know this all too well and are welcoming towards visitors. They understand exactly what has drawn us—and the people that came before them—to their islands, and why we stayed.

Hokkaido is a vast and still largely wild part of the world. A lifetime here would still not be enough time to explore everything there is to see. This book is my Hokkaido, written from a collection of experiences and explorations driven by a passion for these islands. May I note, this book is not a comprehensive guide to every nook and cranny worthy of exploration in Hokkaido—it is merely an introduction that I hope will inspire you to uncover ever more of the wonders the islands of Hokkaido have to offer.

Sapporo & Otaru: Hokkaido's Twin Cities

The twin cities of Sapporo and Otaru are Hokkaido's primary business, government and population centers. One is a thriving metropolis with broad leafy boulevards, a growing skyline and an active nightlife scene; the other a historic seaport with old stone warehouses lining a canal running through its center.

Sapporo is a bustling and relatively new city, Hokkaido's capital and the modern gateway through which almost all visitors to the island must pass. It is strategically located bordering a wide bay along the Sea of Japan to the north and sheltered by steep mountains to the south and west. New Chitose Airport serves as the primary international entry point to Hokkaido and lies within the greater Sapporo area, about an hour south by train from Sapporo's central JR station.

Just a short drive west of Sapporo along the coast, Otaru was once a vital international sea trading port, but is now a relatively quiet seaside tourist town, often regarded as Sapporo's little (although older) brother. While Sapporo's city center lies slightly inland, Otaru is right on the water, rolling back from the coast and up onto steep hills that ring the city.

Although the two cities are closely linked by rail and road, they have distinct and unique personalities and deserve several days to explore. Both are vibrant food and cultural centers and over 2 million people call these cities home—around 2 million in Sapporo and just over 100,000 in Otaru. This may seem tiny compared to Tokyo but large when you consider that Hokkaido's entire population is only around 5 million (less than 5% of Japan) with the majority of those in this small corner of the main island.

Odori Park. A green oasis in central Sapporo looking west to the surrounding mountains.

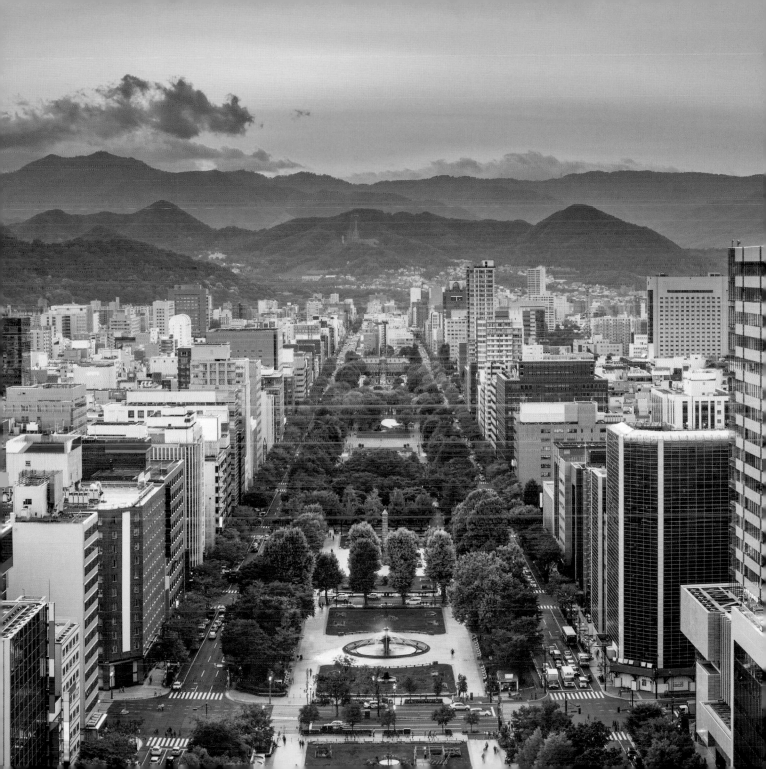

Sapporo: Japan's Fifth Largest City & Hokkaido's Gateway

A sprawling metropolis and Japan's fifth largest city, Sapporo is the beating heart of Hokkaido and its primary hub for commerce and government. This city is very much in sync with the weather, and the mood of its inhabitants seems to adapt to the changing seasons. Cold and icy weather grips the city as it celebrates winter with its famous Sapporo Snow Festival, while in summer the temperate climate brings a green vibrancy to the streets and parklands with flowers, outdoor cafés and beer gardens sprouting in every corner of the urban landscape.

seaport. To the south is Chitose and the main international airport, and to the north and east the vast suburbs give way to farmlands and the expansive wilderness of greater Hokkaido.

Unlike other major Japanese cities, Sapporo has a relaxed vibe to it. People stroll rather than march between traffic lights, and cars weave their way through town at a leisurely pace. Once you enter

Sapporo is laid out in a neatly ordered grid of streets leading from the central train station in all directions like a well-designed mosaic. JR Sapporo Station is the central hub of the city and marks the northern end of Sapporo's main shopping street (Ekimae-dori or Station Street), the city's north-south axis. This intersects Sapporo's other axis, Odori Park, a natural oasis running east-west across the city with Sapporo TV Tower at its eastern end.

Pivoting around these two axes, Sapporo is flanked to the south and west by parks and mountains including 1,742 ft (531 m) Mt Moiwa—still within the city and accessible by cable car—offering dramatic vistas (as well as skiing in winter). To the north is the Ishikari River and the city's oceanside flank and

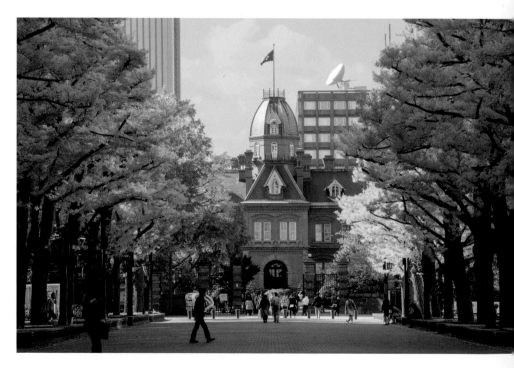

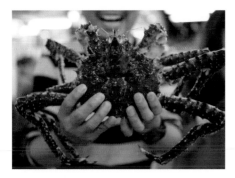

Above The famous Hokkaido king crab is the undisputed king of Hokkaido's seafood and can grow over 3 ft (1 m) long.

Opposite Autumn leaves lining the boulevard leading to the grand red brick building of the former Hokkaido Government Office.

the backstreets, you encounter a maze of one-way lanes and pedestrian and bike-friendly footpaths. This city has a welcoming energy, and the locals are relaxed and friendly.

JR SAPPORO STATION

Start your exploration of Sapporo at the **JR Sapporo Station** the city's main transportation hub. The station is always a hub-bub of people shopping, commuting and socializing around a huge open plaza at the station's southern entrance. An ever-moving throng of happy commuters flows in and out of the main station building feeding into underground walkways, department stores, restaurants and the streets of the surrounding city.

The station is part of a vast interconnected network of buildings housing

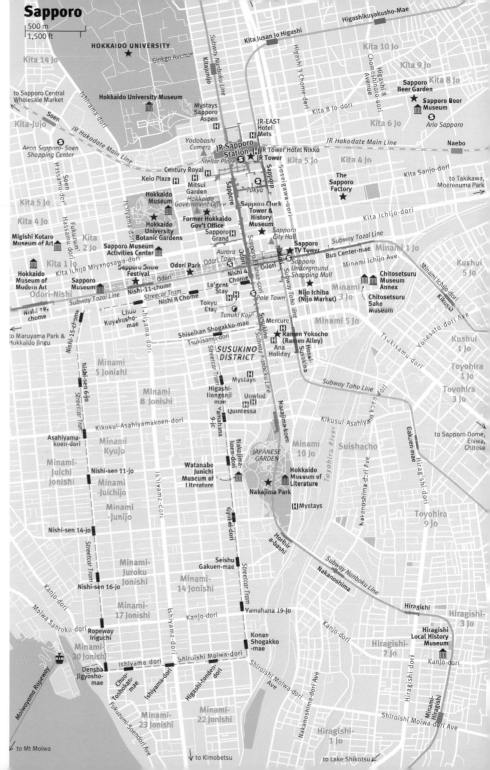

Left The red king crab's meat is known for its high quality, plump and tightly packed texture and exceptional flavor.

Right No evening exploration of Sapporo's Susukino nightlife district is complete without a customary bowl of ramen on the way home.

Below JR Tower and the Sapporo Station shopping precinct.

shops, hotels, food halls and a long underground pedestrian shopping mall that runs north to south beneath the main shopping avenue. To get a good feel for the lay of the land take a quick visit to the 38th-floor observation deck in **JR Tower** (10 am–11 pm, ¥720), where 360-degree views of the city will help you get your bearings.

For another type of experience altogether, make a quick morning visit to the **Sapporo Central Wholesale Market,** located just to the west of Sapporo Station (about a 10-minute train or taxi ride). These bustling market stalls offer fresh seafood and produce with lively vendors happy to haggle while they spruik their wares to the passing crowds. This wholesale market is Hokkaido's largest, supplying restaurants all over the island with the freshest seafood and produce.

The adjacent **Curb Market** shops and restaurants are where ordinary folks can

sample and buy the products. Once the bidding closes at the wholesale market, the adjoining Curb Market shops burst to life and open to the public, typically from 6 am to 5 pm with restaurants

opening at 7 am. This is where you will find the freshest of Hokkaido's famed seafood, and sampling a rice bowl topped with fresh seafood or any type of sushi is highly recommended!

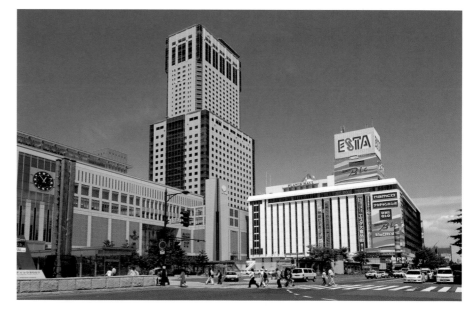

Sapporo Beer: Japan's Iconic Brew

Few things define Hokkaido more than its iconic Sapporo Beer with the original brewery located in the city center, this beer is truly close to the heart of every local. Japan's oldest beer brand—first brewed in 1876—Sapporo Beer comes in three main delicious flavors: Sapporo Black Label, Sapporo Lager and Sapporo Classic.

Sapporo Classic is Hokkaido's defining beverage. Only available in Hokkaido, some locals will tell you it's a good reason to migrate to the island permanently. This tasty beverage is somehow perfectly brewed for the Hokkaido climate and is equally as delicious when drunk from a can in the snow, warm from a backpack on a summer hike, *nama* (fresh) from the tap at a bar, or even out of a plastic cup at a festival. When you buy for a beer in any bar, restaurant or vending machine in Hokkaido you usually get a Classic. You are well advised to drink as much of it as possible while you are here.

SUBTERRANEAN SHOPPING

Sapporo has plenty of ways to relieve you of your tourist dollars. Whether it's food, function or fashion, there is always something to buy and the department stores and indoor malls of **Stellar Place**—around Sapporo Station—provide plenty of choice. Electronics and camera enthusiasts can spend hours exploring two dedicated multi-level stores here. This interconnected commercial maze spans several city blocks and has shop-lined walkways on many levels.

Running for seven blocks (0.7 miles/1.2 km) southward from the station, beneath the main street of Ekimae-dori (Station Street), is an underground pedestrian mall called **Pole Town**, housing a huge variety of stores selling everything from fresh Hokkaido produce to beautifully packaged, weird and wonderful souvenirs.

If you stroll south through this underground shopping wonderland, you'll eventually arrive at **Aurora Town**—a continuation of the underground shopping scene—which runs east-west beneath Odori Park and perpendicular to Pole Town.

THE HISTORIC CBD

On tantalizing summer days you can walk above ground the whole way from JR Station to Odori Park through the heart of the city's bustling CBD. This walk is a nice way to see historical sites and explore some beautiful green areas of the city. The footpaths are wide and flank store-lined streets in every direction. Remember to look up—many stores and restaurants are tucked away on higher floors. Below the street runs the ever-present subterranean walkway traversing the city in the same direction and providing a sheltered pedestrian highway during the freezing winter months.

Two blocks south and west of the station (10 minutes' walk) you will find the attractive former **Hokkaido Government Office** (8:45 am–6 pm, free), surrounded by its own parkland gardens. Built in the 1880s, this beautiful red brick building is topped with a copper dome and houses historic exhibits.

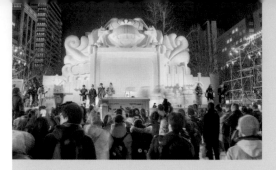

Performers entertaining the crowd from a sculpted ice stage at Sapporo's famous Yuki Matsuri.

Sapporo's Famous Snow Festival (Sapporo Yuki Matsuri)

February is the middle of winter in Hokkaido and Sapporo's streets are often covered in sheet ice. Snow falls consistently and Sapporo is a frozen city from December to February. Losing nothing of its summer energy, the city continues to buzz along in winter with Odori Park a hive of activity and home to the world-famous Sapporo Snow Festival.

The festival had humble beginnings, starting inadvertently when high school students built some snow statues in the park in 1950. Almost 80 years later, it is one of Japan's most popular winter events with an estimated 2 million visitors every year. From these early beginnings the sculptures have evolved into engineering marvels, reaching up to 49 ft (15 m) high, some providing stages for live performances during the festival.

Snow trucked into each block of Odori Park is sculpted into wonders of icy architecture with exacting detail. Every year the sculptures are different and walking around may bring you face to face with the Eiffel Tower, the Taj Mahal or a seemingly life-size Great Sphinx of Giza. Around a dozen of these giant structures fill Odori Park and are accompanied by more than 100 smaller sculptures ranging from cartoon characters to local wildlife or other popular cultural icons. An extension of the festival runs through the streets of nearby Susukino which has a similar number of ice sculptures adorning the wide median strip as the festival continues to grow.

The Sapporo Snow Festival runs for around a week from the beginning of February. The sculptures are accompanied by rows of food and drink tents, and admission is free. You can visit during the day or at night (when the sculptures are illuminated) but remember to dress warmly.

One block further west from the old government house is the expansive **Hokkaido University Botanic Gardens** (9 am–4 pm, closed Mon, ¥420 in summer, ¥120 for greenhouse only in winter)—32 acres (13 hectares) of beautifully preserved parkland in the city's heart. This is a true oasis of natural beauty and a relaxing enclave within the city center. Head here on a warm summer's day to relax and take time out from the busy shopping streets nearby.

Continuing south but crossing to the eastern side of Ekimae-dori (five blocks to the east) will bring you by another of Sapporo's other well-known historical monuments, the **Sapporo Clock Tower and History Museum** (8:45 am–5 pm, ¥200). Built in 1878, this iconic clapboard building—inspired by colonial mid-west American architecture—houses a museum on the history of Sapporo.

Food stalls are a crucial ingredient for any Japanese festival and are always an exploration of delicious creations.

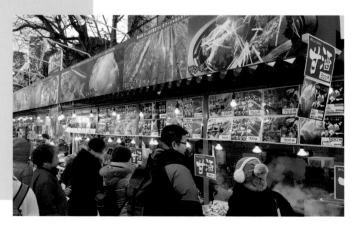

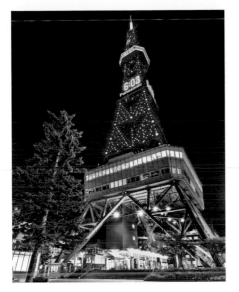

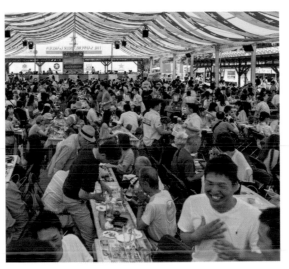

THE EAST-WEST "GREENBELT"

0.7 miles (1.2 km) south of the station, **Odori Park** streaks across the city center, running east to west for 12 blocks, intersecting Ekimae-dori, and dividing the city into distinct north and south sections. It provides a refuge from the surrounding concrete buildings for locals on lunch breaks, weekends and national holidays, as well as welcoming tourists in every season.

Odori Park is home to the world-famous Sapporo Snow Festival in February each year, the Lilac Festival and Yosakoi So-ran (dancing parade) Festival in spring, the Sapporo Odori Beer Garden in summer, and the Sapporo Autumn Fest celebration in September. Much like the locals, the park truly transforms itself with the seasons, morphing and adapting with the weather of Hokkaido.

Above left The Sapporo TV Tower—an illuminated beacon of central Sapporo.

Above Festive crowds enjoying a summer day at the Sapporo Odori Beer Garden in Odori Park.

At the eastern end of Odori Park stands **Sapporo TV Tower** (9 am–9 pm, ¥720). Just under 492 ft (150 m) tall and illuminated at night, it's an iconic landmark and its observation deck provides brilliant views of the park and the surrounding city. Its position at the end of the park provides an uninterrupted view along its length out to the mountains rimming the city's south and western flanks.

SOMETHING'S BREWING

Two other notable historic buildings are located to the east of here (around 20 minutes' walk). **The Sapporo Factory**

(10 am–8 pm), now a modern shopping complex, began life as a brewery with the original building dating back to 1876. Comprised of multiple buildings joined together and crowned by an impressive curved-glass atrium, the mall has 160 different stores, cinemas, restaurants and bars. The historic brick building maintains its atmosphere with a small brewery and beerhall still operating on site today, along with French and Italian restaurants and a handicraft market with many stalls selling souvenirs and local craft items.

Continuing the beer pilgrimage several long city blocks to the northeast (0.9 miles/1.5 km) you can pay homage to the brew gods of Japan with a visit to the **Sapporo Beer Museum** (11 am–8 pm, closed Mon, free). This building was once a sugar factory, built in 1879, before being bought by the Sapporo Beer Company in 1903. The company converted it into a brewery and then into the museum, which officially opened in 1987.

Another of Sapporo's beautiful and historically significant red brick buildings, it was registered as a Hokkaido heritage site in 2004. The building itself is impressive and reason enough to visit the site but the historical information about beer in Japan is fascinating. Like

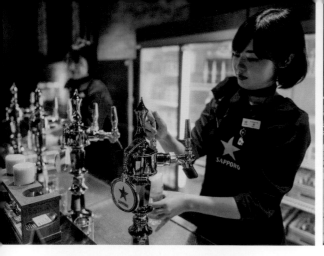

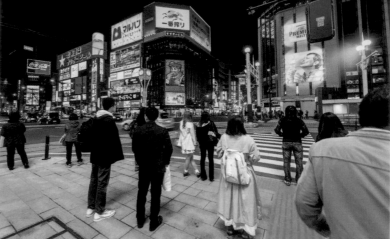

Left The historical building of the Sapporo Beer Museum.

Above left Nothing tastes better than a perfectly poured Sapporo beer, fresh off the tap!

Above The bright lights of central Sapporo and the Susukino nightlife district.

many things in Japan the brewing techniques were adopted from abroad before being perfected for Japanese tastes and style. Entry is free and museum tours are available.

The beer garden on site has several restaurants and a visit to the brewery is not complete until you have sampled some of this exquisite golden ale. There are many options to fill your cup, always with the perfect amount of foam head—measured precisely. You'll find Sapporo beer to be smooth and consistent, no matter which brew you choose.

Left The historical building of the Sapporo Beer Museum.

SAPPORO'S LIVELIEST DISTRICT

Continuing south from Odori Park you enter the **Susukino** district, Sapporo's vibrant and bustling shopping and nightlife hub, and a neighborhood with its own distinctive bohemian flavor. The bright lights, busy streets and vibrant energy of Susukino are in stark contrast to Odori and it's a great place to wander the side streets in search of funky little shops, jazz bars and hidden cafés.

Wandering the streets in this region is like strolling through a wonderland of bars and restaurants where it seems every building has illuminated signage reaching vertically from the sidewalk to the sky. Each sign represents a different bar, restaurant, or nightlife venue, all usually quite small and intimate, and each one as different as the personality of the proprietor and patrons you'll encounter.

Susukino is a melting pot. Night time workers replace day-time shoppers, and

Above left Nothing tastes better than a perfectly poured Sapporo beer, fresh off the tap!

Above The bright lights of central Sapporo and the Susukino nightlife district.

office lights fade as the restaurants and bars come to life. A true 24-hour vibe grips the district whose central beacon is a Nikka Whisky billboard, marking the transition from day into night as it casts a neon glow over the city's main intersection and the nucleus of Sapporo's pulsing energy.

These lantern-clad backstreets are lined with steaming dumpling stands and *izakaya* (Japanese pubs) filled with patrons washing away the working day with beer and frivolity. Susukino could take a lifetime to properly explore with bars tucked into every tiny nook and cranny. When wandering the streets it can be daunting trying to decide which place to choose but it's actually hard to go wrong. A good rule of thumb is to start at the center around the giant neon lights, find a bar or restaurant

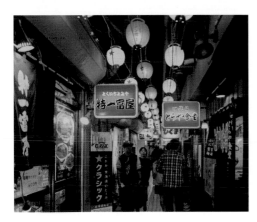

Left Sapporo's famous Ramen Alley, a bubbling hive of soup and noodle delights.

Below The bustling undercover shopping precinct of Tanuki Koji.

that looks like it suits your mood, then work your way back to the darker alleys from there.

As the night wears on and your thoughts turn to a taxi ride home, it's ramen time! Almost a cultural institution after a night out exploring Sapporo's nightlife is a bowl of ramen—and again, there's no shortage of choice. A charming and well-known go to is **Ramen Alley**—a back-alley lined with ramen shops of every description, just two blocks south of the main intersection of Susukino. As with the bars, it's hard to go wrong, so grab the first available seat!

With a satiated stomach it's time to go home. Taxi rides are pleasant as long as you can tell the driver your hotel address (tip: take a business card with you or have the address saved in your phone) and remember the taxi doors are automatic—don't try to open or close them yourself.

SHOPPING IN SUSUKINO

About five blocks south of Odori Park and within the Susukino district is the covered shopping mall of **Tanuki Koji** Sapporo's oldest shopping arcade. This kilometer-long arcade runs east to west along seven city blocks and is home to an eclectic mix of around 200 stores with everything from karaoke bars to secondhand clothing shops, pet stores and gaming arcades. It's a great stroll with plenty to look at whether you're shopping or not. Tanuki Koji is two blocks north of Susukino Station, near the end of the Pole Town underground mall.

The Susukino area around here also offers great shopping and is a fun area to explore in the daytime with many small streets and secluded alleyways. This area is home to a variety of department stores, small fashion outlets and some unique boutique stores tucked away in hidden corners of adjoining backstreets.

If food is your fancy and fish is your flavor, then a great shopping experience is **Nijo Ichiba (Nijo Market)**. This is Sapporo's most central public market, occupying a full city block near the eastern end of Tanuki Koji arcade. It has an authentic feel and is a great place for both locals and tourists to shop for fresh local produce and seafood with crab, salmon eggs, sea urchin and other local delicacies displayed in stalls lining the market. The shops are open from 7 am to 6 pm daily and it has a few hidden restaurants in the central alleyways that offer some of the freshest sashimi in Sapporo.

Further to the south of Susukino is **Nakajima Park,** which defines the southern endpoint of a north-south traverse through the city center along Ekimae-dori. Arguably the city's most popular parkland with a large lake at its center, winding cherry blossom-lined walkways, and hidden Japanese gardens and temples, Nakajima Park is a well-known destination for international and local visitors. The cherry blossoms that burst to life in spring and the

Soup Curry:
A Hearty Hokkaido Speciality

Originating in Sapporo and now considered a local specialty, soup curry is a light curry-flavored soup served with fall-off-the-bone chicken or succulent pork, and colorful vegetables that are flash fried, giving the dish a vibrant palette. Soup curry has grown in popularity to sit second only to ramen in its acclaim and is now a staple of Sapporo cuisine.

The original soup curry is said to have been created by a café in Sapporo in 1971 and was inspired by a Chinese/Korean medicinal soup and curry from Southeast Asia. The soup was a clever adaptation of all these different influences and brought in the wonderful fresh produce of Hokkaido as the key local ingredients.

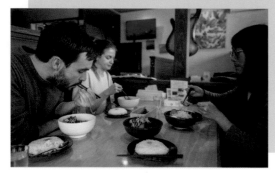

Served steaming hot and filled with nutritious vegetables and flavorsome spiced broth, this wholesome curry dish is one of the best cure-alls on a cold and snowy winter day in Hokkaido. Typical ingredients include pumpkin, eggplant, potato, carrot, capsicum and okra to accompany healthy portions of either chicken or pork. A relative newcomer to the Japanese cuisine scene, soup curry is now widely available in Sapporo and across the island, and a must-try dish during a trip to Hokkaido—particularly in winter!

brilliantly colored foliage of autumn highlight the most beautiful seasons, providing idyllic and romantic settings, making this park particularly popular for couples.

Sapporo is a large city but never feels claustrophobic. While the density of the city center provides everything at your fingertips, you are never far from a quiet corner to sit and watch the world go by.

THE WESTERN HILLS: A PILGRIMAGE TO THE SHRINE

To the west of Sapporo, upper-class suburbs reach into the foothills wrapping the city's western flanks. The most significant of these inner-city hills is **Mt**

Moiwa, a fantastic place to get an overall view of the entire city—particularly after sunset. The observation tower, accessed by the **Moiwayama Ropeway** (10:30 am–10:30 pm, ¥1,700

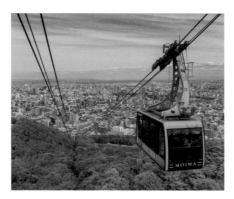

return for ropeway and cable car), sits at 1,742 ft (531 m) and provides panoramic views encapsulating everything from Ishikari Bay to the west, the city center split by the serpentine Toyohira River with its green banks winding through the city, and the gleaming silver beacon of the **Sapporo Dome** to the east. The observation station houses a restaurant, a planetarium and a theater.

Just to the north of Mt Moiwa are peaceful, leafy suburbs, far removed from the bustling city nearby. The calm

Left Moiwayama Ropeway with views over Sapporo city below.

seems to resonate from a central feature of this side of the city, **Maruyama Park**, one of the best places to see cherry blossoms coming to life in vivid color through the months of April and May. The large park is also home to a baseball field, athletics track, tennis courts and sports fields, as well as the Sapporo City Maruyama Zoo. A short walk will take you to the top of Mt Maruyama, whose peak sits at 738 ft (225 m) and offers views back over the city.

Sapporo is home to several temples and shrines but none more significant or beautiful than **Hokkaido Jingu** (Hokkaido Shrine, 6 am–5 pm [7 am–4 pm in winter], free), built in 1871 and encapsulated in the vast Maruyama Park. The temple itself has expansive grounds and a serene and peaceful feel, with huge torii (traditional Japanese gate denoting the transition into sacred sites) marking the entrance.

The shrine holds obvious cultural and religious significance but is open to the public to freely wander through its grounds. When entering through the gates of the shrine, etiquette asks that you avoid walking through the center of the middle gate as this is known as the causeway of the gods. This also applies when you take photographs of the torii—avoid shooting from the absolute central path to show respect for Shinto beliefs.

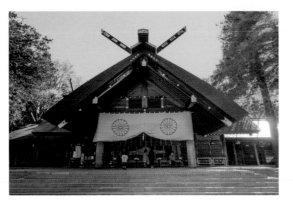

ETHEREAL PARK BEAUTY
A large park on the northern edge of the city, **Moerenuma Park** (7 am–10 pm, free) was designed by famed Japanese-American sculptor Isamu Noguchi and opened in 2005. Noguchi's concept was for the whole park to be a single work of art and it truly feels like an intricately connected place, with gorgeous landscaping and architecture centered around a glass pyramid—the park's crowning jewel.

Top Hokkaido Jingu is a Shinto shrine that enshrines four kami (Shinto deities) including the soul of the Emperor Meiji.

Below The architectural pathways of Moerenuma Park.

As part of Sapporo's green-belt movement in the early 1980s, the park was converted from a waste treatment plant and is adorned with 3,000 cherry blossoms and beautifully manicured and sculpted hills and pathways. This reserve for recreation has sports fields and play equipment making it an attractive place for weekend family day trips, particularly during the spring and summer months.

HOME TO THE HAM FIGHTERS
Just as important as skiing to Sapporo locals is the sport of baseball, and a trip to the iconic **Sapporo Dome** on the city's southeastern outskirts is a great way to experience Japanese sporting culture first-hand. The season runs from the end of March to mid-October with around 60 home games a year. Tickets start at ¥1,200 for kids and ¥1,700 for adults. The stadium—a futuristic monolith—is a 15-minute subway ride from almost anywhere in the city and if a game is on, you will arrive amongst throngs of excited local fans.

Choreographed cheerleading squads, booming drums and rehearsed chants fill the stadium while roving servers pour beer from refrigerated backpacks and bring hotdogs to you in your seat. The atmosphere is a bubbling cauldron of energy and games can be so much fun in the stands, it almost doesn't matter if the Fighters don't win... Almost!

Sidetrips Around Sapporo:
An Area Filled with Surprises

No matter what time of year you visit Sapporo, there are plenty of options for day trips and longer excursions to get out of the city and enjoy the beautiful scenery in every direction. Easily accessible from the city center are numerous opportunities to enjoy the art, architecture and history of the region—especially in neighboring Otaru—as well as picturesque mountains and lakes for skiing, hiking and swimming.

PRE-MODERN HOKKAIDO

About 11 miles/18 km (35 minutes' drive or 35–40 minutes' train or bus-ride) to the east of the city center, the **Historical Village of Hokkaido** is a collection of historic buildings dating back to the days before modern construction methods. Hokkaido was at that time a remote and sparsely populated place and buildings were constructed with a natural material that the island has in great abundance—timber. A visit to the village (9 am–4:30 pm, closed Mon, ¥600) is a perfect way to step back to earlier days in Hokkaido. The village is located in the **Nopporo Forest Park**, a huge wilderness area on Sapporo's eastern outskirts. There are about 60 buildings from all over Hokkaido, dating from around 1868 to 1926.

Also in the park and just a 10-minute walk from the historical village is the **Hokkaido Museum** (9:30 am–4:30 pm, closed Mon, ¥600), which documents the nature, wildlife and history of Hokkaido—including that of the indigenous Ainu culture—and is worth incorporating as part of a day trip to this side of the city.

Below left The Historical Village of Hokkaido. Step back in time in this open-air museum in Sapporo's east.

Below Inside a meticulously restored traditional house from the early 19th century, one of 52 historical structures at the Historical Village of Hokkaido.

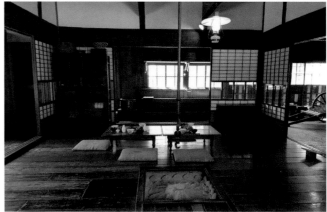

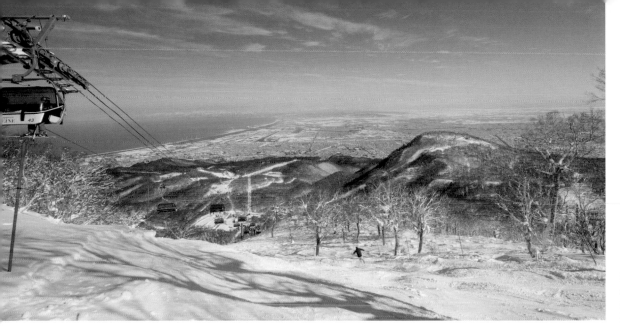

Striking views over Sapporo city and Ishikari Bay from the nearby Sapporo Teine ski resort.

SAPPORO'S BEST SKI RESORT

About 12.4 miles/20 km (40 minutes' drive or 50–80 minutes' ride on "Big-runs" bus; "bus pack" round trip ticket & 8-hour lift pass ¥6,900 for adults, ¥4,400 for children) west of the city towards Otaru, **Sapporo Teine** is the largest of several ski resorts on the outskirts of Sapporo and offers brilliant views to the Sea of Japan and back over the city itself from its 3,281 ft (1,000 m) peak. Perhaps its greatest claim to fame is its two runs used for ski events during the 1972 Sapporo Winter Olympics, and the Olympic torch still stands above the resort, testament to its days of international renown.

Skiing here with expansive views out over the ocean is a unique experience and something you are able to do in just a handful of places worldwide. Teine is a great ski resort with varied

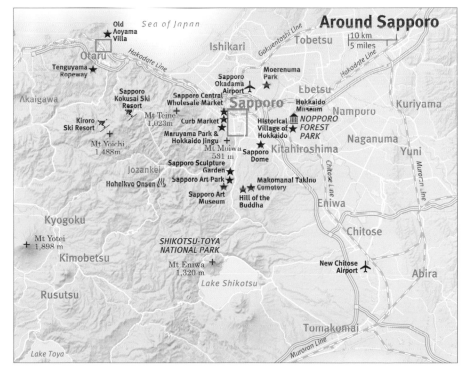

Lake Shikotsu: A Stunning Mountain Lake

An hour's drive (28 miles/45 km) south of Sapporo, **Lake Shikotsu (Shikotsuko)** is a wonder to behold—a huge and incredibly deep body of water filling an ancient volcanic crater. Plunging to a depth of 1,191 ft (363 m), it's the second deepest of Japan's lakes and certainly one of its most spectacular. Rising high above the water on the lake's northeast edge is the ominous **Mt Eniwa (Eniwa-dake)**, a steep and rugged mountain with steam emanating from its peak.

Lake Shikotsu is surrounded by wilderness with the small township of Shikotsu nestled on its eastern shore. A road winds its way around much of the perimeter of the lake and is the best way to explore its sandy shores and various water-side stops and view points. Dotted around the lake are several summer camping locations, all with different approaches to lakeside life and options ranging from rugged tent sites to luxurious onsen hotels. Just an hour from Sapporo, Lake Shikotsu is a convenient and tranquil escape from the busy city either for a day trip, overnight or week-long camping adventure. A swim in the lake's cool waters is the perfect relief on a hot Hokkaido summer day, or after returning from a hike in the nearby mountains.

Due to its size, it's difficult to see the lake in its entirety from any one of the waterside roads or campsites. The best way to truly appreciate its magnificence is from the top of Mt Eniwa. A challenging hike through heavily forested foothills and steep, rugged ridge-lines, it takes a determined trekker to reach the top. Once you reach the summit above the steaming vents of the volcano, the true wonder of Lake Shikotsu is laid out beneath you, a beautiful circular expanse of water which melts from blue to green where it meets the forested shoreline.

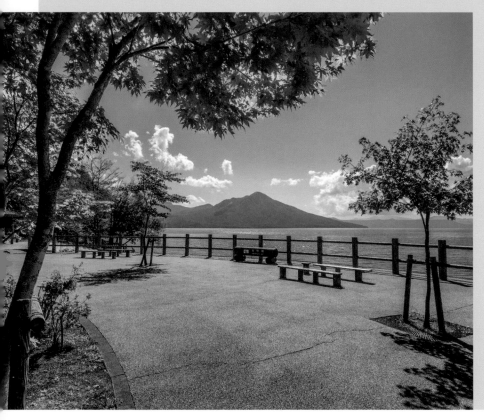

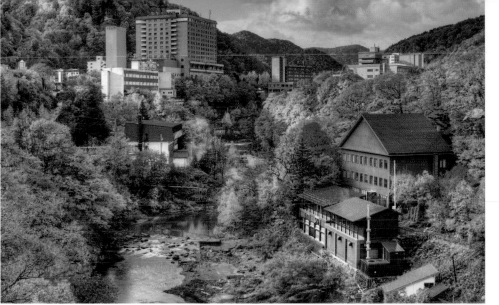

runs, from beginner to advanced, with backcountry options for experts and adventurers. Mt Teine is also a popular spot for summer-time hikes—around six hours return trip on a well-defined trail and can be especially beautiful in October as the autumn colors take over.

A HOTSPRING PARADISE

A short drive to the southeast (18.6 miles/30 km, 45 minutes) of Sapporo's hustle and bustle, a winding road brings you through the sprawling suburbs, past orderly streets and into the wild region of **Jozankei.** This deep natural gorge is a popular onsen (hot spring) resort for Sapporo residents and fast becoming a mountain retreat for international visitors.

This stunning year round destination is at its most glorious in autumn when the foliage seems to shimmer like a burning tapestry across the mountains.

Above The striking autumn colors in the hot spring resort of Jozankei.

Above right One of Jozankei's many fairy tale *kappa* statues. Based on old stories of a water goblin, each statue is unique and they can be seen dotted throughout the town.

Right "Yuki torou" or snow candle festival, held yearly in late January to early February at the Jozankei Jinja (shrine).

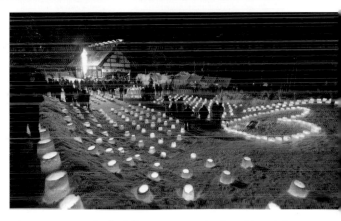

Not a large town, Jozankei is nice to explore on foot, wandering the streets and taking in the scenery from the several bridges that cross the Toyahira River as it drains the mountains and flows north towards Sapporo. Jozankei is the perfect destination for an overnight or weekend escape from Sapporo with a wide range of hotel options, most offering the typical Japanese package

deal of dinner, onsen, bed and breakfast.

Sapporo Kokusai Ski Resort is just a 30-minute drive from Jozankei, making this area an ideal recuperation stop on a skiing day trip. **Hoheikyo Onsen** is in the mountains about five minutes' drive from Jozankei town center; a beautiful natural onsen and perfect stop before you return to downtown Sapporo—there is also a tasty

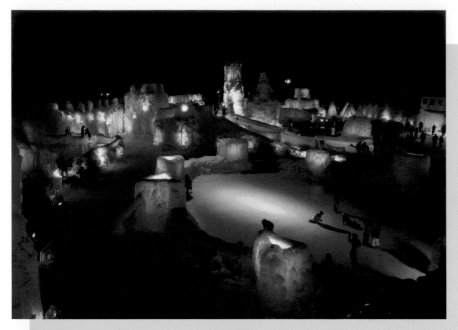

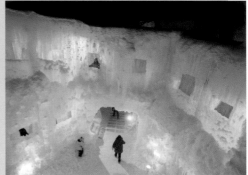

Left Overview of the illuminated structures and frozen ice rink at the Lake Shikotsu Ice Festival.

Below Exploring the multi-level ice structures and their many pathways and tunnels.

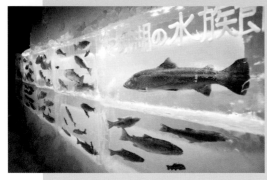

Above Fish frozen in a wall of ice at the Lake Shikotsu Ice Festival.

The Lake Shikotsu Ice Festival

Shaped by the wildly divergent weather, each of Hokkaido's beautiful locations adapts in celebration of the seasons. As Lake Shikotsu slowly transforms from one of Hokkaido's thriving summer playgrounds, an icy contrast emerges with Shikotsu Town on the lake's eastern shore hosting an ice festival of its own. Less well known to international visitors, the Lake Shikotsu Ice Festival is a miniaturized and more intimate version of Sapporo's world-famous snow festival. The festival is created by spraying and freezing water from the lake to form a frozen playground of ice slides, sculptures and a fun children's area where you can slide around in boots like an ice-skating rink. There are food and drink stalls and horse rides around the venue, making this a fun family event every year from the end of January to late February (free).

At night the event comes to life. Walking among the glowing statues, lit by colored lights and glistening in the cold night, the festival feels like a wonderland with an otherworldly feel—vastly different from the lake's warm and welcoming summer vibe. This festival is worth a day trip from Sapporo or overnight stay in one of the comfortable onsen hotels in the town.

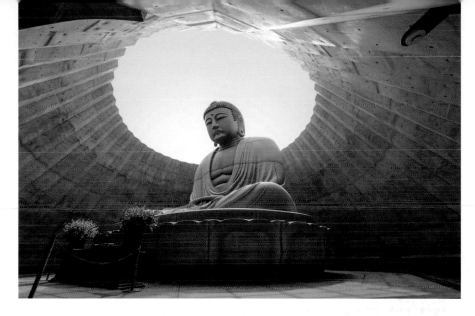

4 pm, free) and the monumental architectural artwork of Tadao Ando—specifically the **Hill of the Buddha**. An award-winning and globally renowned architect, Ando has several acclaimed buildings in Hokkaido, in this instance an enormous, lavender-covered temple surrounding a giant statue of Buddha.

The cemetery also has about 40 Moai (Easter Island) heads running along the side of the road into the park, where further on you will find a full-size replica of Stonehenge.

Indian curry restaurant in the main onsen building!

LANDSCAPE ART

Heading south from Sapporo (30 minutes' drive, 10 miles/16 km) brings you to two notable architectural sites; **Sapporo Art Park** and **Makomanai Takino Cemetery**. Located relatively close to each other it's easy to visit both of these in a half-day trip from the city or as part of a longer excursion to Lake Shikotsu.

Sapporo Art Park (9:45 am–5 pm, free [¥700 admission to sculpture garden]) is home to **Sapporo Art Museum** and a **Sapporo Sculpture Garden**, hosting both permanent and temporary exhibitions across vast grounds that change with the seasons.

Further along the road (15 minutes' drive, 3.7 miles/6 km) you will find Makomanai Takino Cemetery (8:45 am–

Above The Hill of the Buddha is a Buddhist shrine at Makomanai Takino Cemetery. The 44 ft (13.5 m) tall statue of the Buddha is encircled by an artificial hill rotunda planted with 150,000 lavender plants.

Below The impressive rows of the 33 ft (10 m) tall Moai statues running along the roadside.

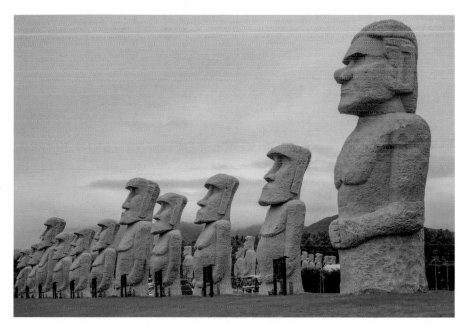

Otaru: A Journey Back in Time

Otaru's charm lies in its old-world feel. The city occupies a stretch of coastline looking north and east across Ishikari Bay with tall mountains bordering its southern flanks. Through its heart flows the Otaru Canal, lined by beautiful old stone warehouses and stores harking back to a vibrant past when the city was the primary center of the region with the vast majority of trade coming through its ports.

A picturesque sunset over the tranquil and historic Otaru Canal and warehouse area.

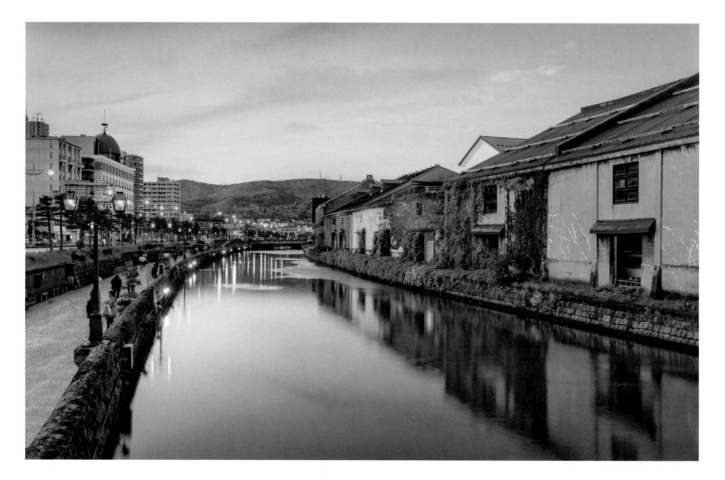

26

Above Take a ride with a local on a traditional rickshaw and explore the streets of the city.

Below An artist creates his version of the Otaru Canal from the vantage of one of its several bridges.

Right Tourists discovering local sites and sweet treats on the streets.

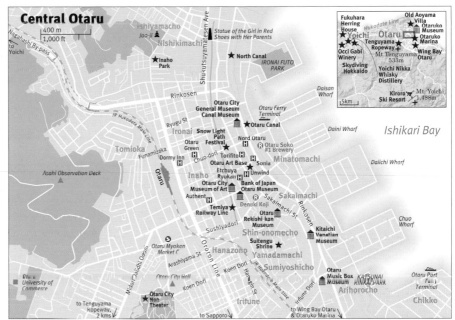

Central Otaru

400 m
1,000 ft

Ishiyamacho
Joo-ji
Nishikimachi
Statue of the Girl in Red Shoes with Her Parents
North Canal
IRONAI FUTO PARK
Inaho Park
Nagahashi By-pass
to Yoichi
Rinkosen
JR Hakodate Main Line
Otaru City General Museum Canal Museum
Otaru Ferry Terminal
Daisan Wharf
Daini Wharf
Ishikari Bay
Ryugu-ji
Ironai
Snow Light Path Festival
Nord Otaru
Otaru Canal
Otaru Soko #1 Brewery
Tomioka
Otaru Green
Dormy Inn
Torifito
Chuo-dori
Funamizaka
Otaru Art Base
Sonia
Minatomachi
Daiichi Wharf
Asahi Observation Deck
Etchuya Ryokan
Unwind
Otaru City Museum of Art
Bank of Japan Otaru Museum
Inaho
Otaru
Authent
Denuki Koji
Sakaimachi
Temiya Railway Line
Otaru Rekishi-kan Museum
Sakaimachi St.
Rinkosen
Chuo Wharf
Sushiyadori
Kitaichi Venetian Museum
Shin-onomecho
Otaru Myoken Market C
Suitengu Shrine
Otaru Daichi Dori
Arashiyama St.
Hanazono
Koen Dori
Ororon Line
Yamadamachi
Sumiyoshicho
Hanazono Main Street
Irifune Dori
Otaru Music Box Museum
KATSUNAI HINAI PARK
Arihorocho
Otaru Port Ferry Terminal
Chikko
Otaru University of Commerce
Otaru City Hall
Koen Dori
Irifune
Otaru City Noh Theater
to Tenguyama Ropeway, 2 kms
to Sapporo
to Wing Bay Otaru & Otaruko Marina

Fukuhara Herring House
Hakodate Line
Old Aoyama Villa
Yoichi
Otaru
Otaruko Museum
Occi Gabi Winery
Tenguyama Ropeway 533m
Mt Tenguyama
Otaruko Marina
Skydiving Hokkaido
Yoichi Nikka Whisky Distillery
Wing Bay Otaru
Kiroro Ski Resort
Mt. Yoichi 1,488m
5km

This past was the foundation for significant wealth and powerful fishing merchants constructed grand homes and buildings throughout the city, many of which have been preserved and restored. Closely linked to Sapporo, Otaru is a city in its own right with a much smaller population and more local feel. Most people visit Otaru as a sidetrip from Sapporo, as the road and rail connections are very good and Sapporo has broader accommodation options.

LIFE ON THE OLD CANAL

Otaru is a 45-minute train ride from Sapporo and arriving at the main train station places you in the city's center. The station has a slightly elevated view and from here the main road—Chuo-dori—falls away over several blocks toward the canal and harbor.

This is a great place to start an exploration of the city and on a stroll downhill (1,640 ft/500 m) you will cross the disused **Temiya Railway Line,** Hokkaido's oldest railroad (dating back to 1880), now converted to a park-like path running almost the width of the city from north to south, parallel to the canal. This is a nice walk in summer

months and a pleasant way to get from one side of the city to the other. It's perhaps even more beautiful in winter, when **Otaru's Snow Light Path Festival** illuminates the historical thoroughfare.

A few blocks (820 ft/250 m) further down the hill will bring you to **Otaru Canal.** This part of Otaru is certainly the most recognizable and probably the first thing that comes to mind when

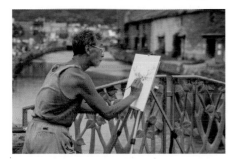

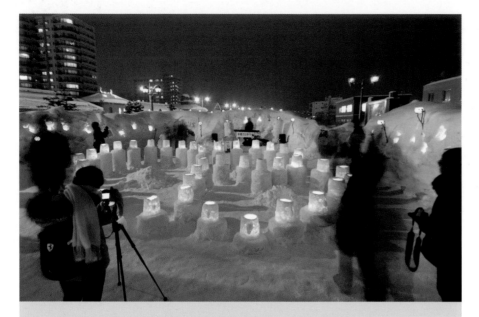

Otaru's Snow Light Path Festival

Every February the historic heart of Otaru comes to life under the glow of the **Snow Light Path Festival**. Lanterns and candles adorn the sidewalks in custom-built statues and snow creations, and float dreamily down the historical canal. The streets are lit by gas lanterns and illumination flickers everywhere, bringing a warm vibrancy to this winter festival.

The festival comes to life every evening along a section of the canal and through the pedestrian parkland of the disused Temiya Railway Line. Locals have embraced the tradition with many homes and restaurants hanging lanterns by their entrances, adding to the festive energy of the town. As with most festivals in Japan, food stalls are ever-present and there are plenty of restaurants and bars close by if you want to cosy up with a cup of hot wine.

A relatively young event, having first illuminated Otaru's canal side in 1999, the festival runs for 10 days in tandem with the Sapporo Snow Festival, providing tourists with the perfect excuse to visit Otaru for a night or two in winter and enjoy both festivals during the same trip.

people refer to the city. Constructed in 1923 the canal became obsolete when Otaru's modern port opened. The canal has been beautifully restored and the old warehouses transformed into museums, shops and restaurants.

Exploring the canal area can be done on foot, by bicycle, boat or even in a rickshaw. The southern part of the canal is lively in every season and be sure to explore the warehouses on the eastern side where you will find the famous **Otaru Soko #1 Brewery** (11 am–11 pm) along with several other restaurants, cafés and shops.

Running parallel to the canal is the main road through Otaru and lining this street are tourist-oriented restaurants and shops. Still a thriving sea port, Otaru is famed for its fresh seafood—boasting over 100 sushi restaurants—and a wander down this main road will bring you face to face with live king crabs and various seafood oddities breathing bubbles in their watery cages. The famed "sushi street" with over 25 specialist sushi restaurants runs for about 820 ft (250 m) from the southern end of the canal climbing a slight hill back toward the city center.

Along this strip you will also find **Denuki Koji** (opening hours vary but generally 11 am–8 pm), a quaint mix of around 20 interesting shops collected together under a striking bell tower. Connected by small alleyways, this is a fun area to explore for a variety of food and bar options. There is also an

Hokkaido's Last Geisha

Perched on the northern cape in the hills above the cliffside, with panoramic ocean views, is **Old Aoyama Villa** (9 am–4 pm, ¥1,000). Of all of Otaru's lavish villas, this is by far the most extravagant and has been meticulously restored and maintained over its 100-year lifetime. Built with the wealth of several generations of a herring fishing empire, the villa resembles a palace more than fisherman's home and is now a designated historical residence.

The beautiful timber hallways, screened by ancient rice-paper walls, lead you through the villa where, for just a few days in February every year, you will find the last of Hokkaido's geisha. With just seven remaining authentic geisha on the island, encounters are rare and in one of Otaru's most historic buildings this is an enriching interaction with one of Japan's ancient cultural traditions.

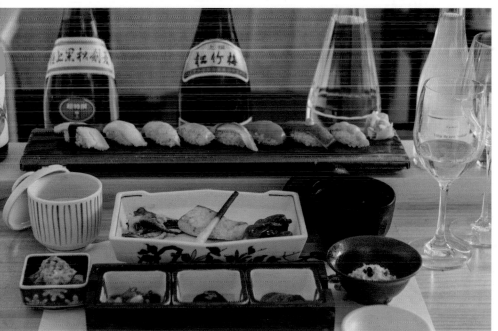

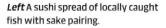

Left A sushi spread of locally caught fish with sake pairing.

observation deck in the tower that offers a great view over the canal area and has free admission.

To get off the beaten track, go searching through the back streets of this precinct to find local hangouts and experience authentic Otaru culture in tiny *izakaya*, secluded bars and delicious seafood restaurants hidden in these funky backstreets.

GLASS AND TREASURE HUNTING

Arriving at the southern end of the **Otaru Canal** will bring you to the city's popular tourist precinct of **Sakaimachi.** Harking back to its bountiful fishing past, when nets required glass floats, Otaru is now famed for its quality

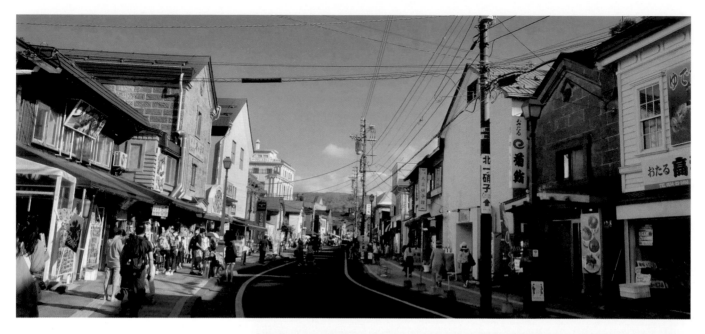

Above The busy tourist strip of Sakaimachi Street with its many shops and bustling vibe.

Right Inside the Otaru Music Box Museum.

glassware. It's in Sakaimachi where this tradition lives on and you will find a long, pedestrian-friendly street lined with cafés, galleries and shops selling glass works and offering glass blowing classes—a fun way to create your own authentic souvenir!

Sakaimachi Street (Sakaimachi-dori) is an attractive and preserved merchant street, close to the harbor but tucked in behind buildings which hide this quaint area from view of the main road. This area certainly has a more touristy feel and souvenirs are in plentiful supply.

Curiously, Otaru is also famous for

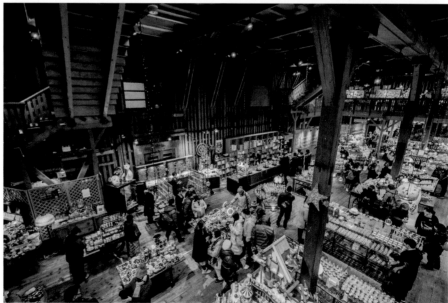

music boxes and is home to the **Otaru Music Box Museum** (9 am–6 pm, free). Following Sakaimachi Street all the way south (0.5 miles/750 m) will bring you to the museum, a beautiful brick building dating back to 1912. Inside you will find every variation of music box imaginable, many available to purchase, as well as an interesting historical archive of antiques. In front of the building stands a steam clock—a present from the city of Vancouver and one of only two in the world!

Sitting on a hilltop above the bustling area of Sakaimachi, a 15-minute stroll from the canal, is **Suitengu Shrine** (7 am–6 pm, free). The view from here will quickly give you a perspective of the area below and the canal and harbor beyond. The original temple building dates back some 150 years and is a designated historical building of Otaru.

Beyond Sakaimachi to the south (1.2 miles/2 km) is the modern **Wing Bay Otaru** (10 am–9 pm but shop hours may vary) shopping and cinema megaplex. An enormous shopping center complete with its own sky wheel, this can be a good option on a bad weather day when wandering the streets doesn't seem like it will be much fun. The complex overlooks the **Otaruko Marina**, which is a charming harbor for private boats and in warmer months provides a maritime option to explore the cliff lined coastal waters around Otaru with boat charters and tours.

SKIING AND SCENIC VIEWS

Rising 1,749 ft (533 m) above Otaru is **Mt Tenguyama**, one of the best places to take in an all-encompassing view of the city and its surrounds. Just 15 minutes' drive west from the main train station, the cable car takes visitors to the observation deck to enjoy one of the best night views in Hokkaido. The ropeway also ferries skiers and

snowboarders in winter (December–March) and the slopes below the cable car become the city's own ski field, overlooking the city and Ishikari Bay. The ropeway runs from 9:30 am–9 pm and is closed for inspections in April & November (¥1,200 adults, ¥600 children).

Beyond the visible hills surrounding the city, taking the mountain road of National Highway 393 deeper into the mountains (15.5 miles/25 km, 30 minutes' drive) you will find **Kiroro Ski Resort**, a large resort with extensive lift infrastructure and facilities and another of Hokkaido's well known international ski resorts.

Left Views looking towards Mt Yoichi from the top of Kiroro Ski Resort.

Bottom The cable car ascending Mt Tenguyama above Otaru city.

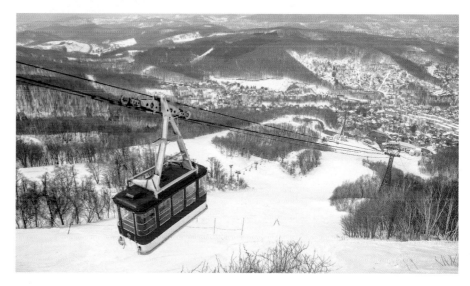

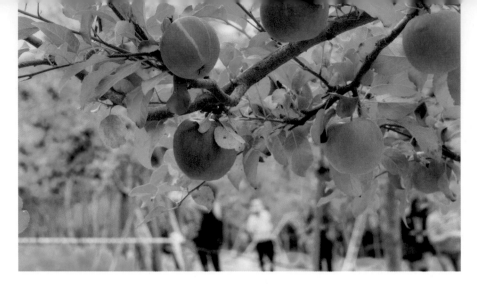

Yoichi: Fruit Orchards, Seafood & Whisky

Tucked away on the coastline between Otaru and Shakotan is the small fishing town of Yoichi, a 30-minute drive or 25-minute train ride from Otaru. Also known for its fruit, orchards and wine, the heart of the town is centered around the large brick buildings of its famed whisky distillery.

Cherries, apples, grapes and blueberries grow here, amongst others, and fruit picking offers both employment for the locals and an activity for tourists, day-trippers and weekend visitors from Sapporo. A car will help you access and enjoy some of the sights Yoichi has on offer but if you're on foot you can still enjoy a visit to the distillery and a stroll around the harbor.

If you visit in summer, the harbor is the scene for the local *matsuri* (festival) and water's edge seats are at a pre-

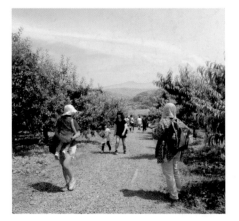

mium for fireworks displays launched from the outer-harbor walls and reflected in the waters below. The **Yoichi Soran Festival**, held every year during the 2nd weekend of July, is a great time to visit and sample the local seafood, with dozens of stalls offering gigantic scallops cooked over hot coals and other local delicacies, many caught that very morning.

During the Edo period, herring flourished in the area's coastal waters and consequently Yoichi is home to many fishing industry-related buildings, constructed by the powerful merchants of the time. Just a 10-minute drive from the center of town, on the road to Shakotan, you will find the historic site of **Fukuhara Herring House** (9 am–4:30 pm, closed Mon in winter, ¥300 adults, ¥100 children) and a glimpse into life at the height of the herring trade some 150 years ago.

WINE

While whisky is synonymous with the name Yoichi, wine from the area has a growing reputation of its own. The region is producing some very commendable vintages and a visit to the **Occi Gabi Winery** (11 am–5 pm, free) is

an interesting experience for wine lovers. In its picturesque setting in the hills bordering the town, Occi Gabi is a pleasant setting to enjoy lunch paired with wines produced from locally grown grapes and learn more about the short history and potential future of Hokkaido wine.

SKYDIVING
There's plenty to see at ground level, but from 30,000 ft (9,144 m) up it takes

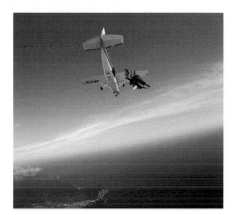

on a whole new perspective. **Skydiving Hokkaido** bases its operations out of Yoichi, where the ocean is a vibrant turquoise blue, contrasting against the rich green inland. Fly up in a six-person Cessna and launch into the Hokkaido sky.

Left Drop from the sky to experience thrilling views over the spectacular coastal area of Yoichi and Shakotan Peninsula reaching out into the deep blue Sea of Japan.

The World-Famous Nikka Whisky Distillery

The cold winters of this coastal town are shouldered by crisp spring and autumn months and a temperate summer. This special climate provides the optimal conditions for fruit growing and also brought the now world-famous Yoichi Nikka Whisky Distillery (9:15 am–5 pm, free) to the town. Founded in 1934 and rolling out the first barrels of blended whisky in 1940, the building itself is an historical icon and the pride of this small fishing township. A visit to the site involves an easy stroll through the buildings and includes the opportunity to sample some delicious and rare whiskies, as well as a store to purchase bottles of vintages you may not find anywhere else.

The distillery was the personal project of legendary Japanese whisky figure Masataka Taketsuru. After studying whisky making in Scotland, Taketsuru worked for Suntory where he helped establish the Yamazaki distillery—home to Japan's other iconic whisky. He soon left Suntory to establish his own distillery at Yoichi, on the site he had initially chosen for Yamazaki, believing it to most closely match the climate of Scotland. With an abundance of clean water and fertile soil, it's of little surprise that the distillery has come to produce some of the most sought-after whisky in the world.

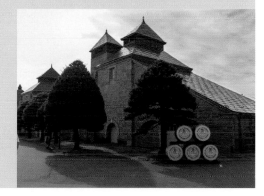

Yoichi was awarded the prestigious prize of "Best Single Malt" at the World Whisky Awards in 2008—the first time a Japanese whisky had won such an illustrious award. This sparked the current international interest in the product and after an accompanying boom in domestic consumption in 2014, the global supply is now limited while production tries to catch up to demand.

Southwest Hokkaido: Asia's Newest Playground

Southwest Hokkaido is the islands' adventure hub and a region of diversity that boasts some of the world's best skiing and some of their most scenic landscapes. As the snow-covered winter playground gives way to a temperate summer, the lakes, rivers, oceans and mountains—along with the area's farms and their famed fresh produce—explode with color and life, transformed by the green season.

Extending south from Sapporo this region is wedged between two oceans and punctuated by pristine lakes and myriad volcanic mountains, none more iconic than the ever-present Mt Yotei —the heart of the Niseko skiing and onsen resort area. Niseko's Annupuri mountain range rolls back to the ocean at Iwanai, one of Hokkaido's oldest towns—dating back to 1751—and the gateway to the spectacular Shakotan Peninsula. The peninsula is renowned for its black, cliff-lined shores plunging into turquoise blue ocean and is home to one of Hokkaido's most spectacular seaside drives.

The western coastline follows the Sea of Japan south with the road clinging to the shoreline as it weaves through this wild and mountainous region. This long, winding road is sparsely populated, broken intermittently by quaint fishing villages, and branches off occasionally to cross the mountains to the east.

Lake Toya is the region's most recognized lake and the central point on the Pacific Ocean side, an area also well known for the nearby onsen town of Noboribetsu. Southwest Hokkaido stretches further south along the Oshima Peninsula, wrapping around to the multicultural center of Hakodate, the largest city in the south and its primary hub.

Floating through a sunset powder turn in Niseko's perfect snow at the foot of Mt Yotei.

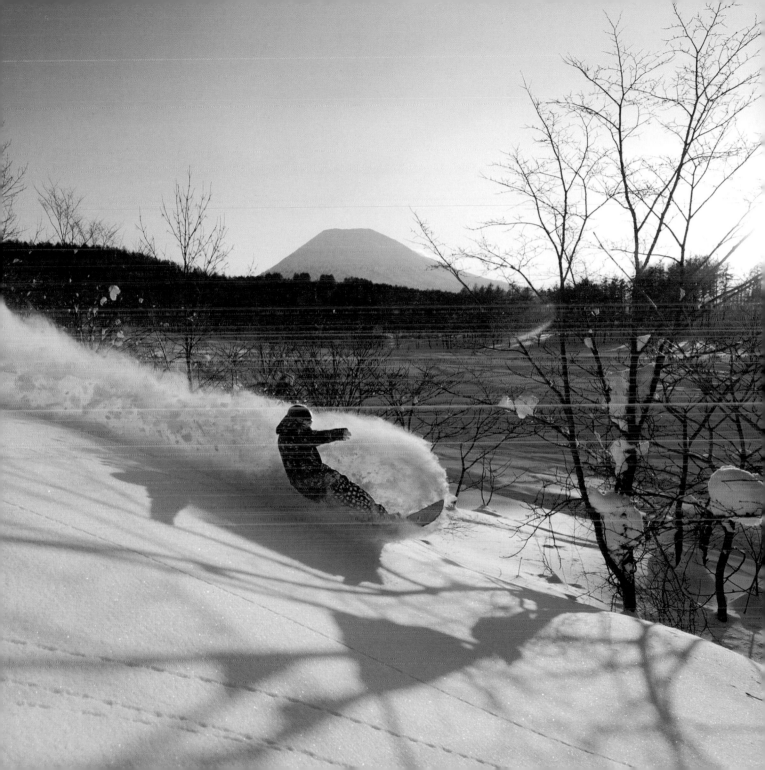

Exploring Hakodate:
The City of Lights

Hakodate is a city of vibrant markets and ocean-side energy. The third largest city in Hokkaido and gateway to the main island of Honshu, Hakodate has its own unique identity forged by its multicultural past. It is easily identified by the breathtaking views of shimmering lights emanating from the city, which is wedged onto a narrow peninsula beneath the summit of Mt Hakodate at the very southern tip of Hokkaido. Its claim to fame is seafood and, in particular, squid.

The city's early history, like many other coastal cities in Hokkaido, centers around fishing and trade. Its wide, protected bay and proximity to Honshu made it the ideal base for early pioneers seeking to trade with the indigenous Ainu people, then the island's main inhabitants. Hakodate was the largest city in Hokkaido until the Great Fire of 1934, in which more than 2,000 people died and 11,000 buildings were destroyed. In 1954 Hakodate's port was the first in Japan to open up to international trade.

The city is serviced by a small international airport and a large port, with regular ferries serving several centers on Honshu, and is linked to the rest of Hokkaido by highways, rail and scenic oceanside roads. If traveling from Tokyo the Shinkansen (bullet train) provides a rapid overland/undersea option.

Hakodate's charming historical character is visible everywhere as you wander through the city. A small network of trams connects the popular tourist sites, meandering through the streets lined with old buildings housing modern cafés and stores.

PREMIUM SEAFOOD AND PRODUCE

Located just a short stroll (656 ft/200 m) from Hakodate Station on the city's western bayside, the **Hakodate Morning Market** (5 am–3 pm, stores may

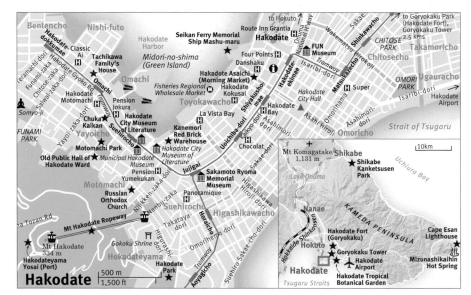

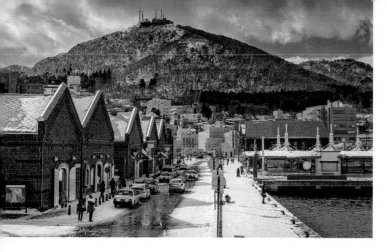

Left The waterfront Kanemori Red Brick Warehouse is a great place to wander and enjoy the historic feel of the city.

vary) is a gigantic market with everything from seafood to sweets and a large number of restaurants serving squid and specialty seafood rice bowls. Open throughout the year, this is a great place to start your morning with a local experience and prepare yourself for a day exploring the city.

Alternatively, you can try the **Free Market** (8 am–5:30 pm, stores may vary, closed Sun)—about 15 minutes' (0.6 miles/1 km) walk towards the city's residential center—another fresh produce market that is famed for its top-quality seafood and being where the top chefs shop.

THE WATERFRONT
Located on the waterfront, a 20-minute (0.8 miles/1.3 km) walk south from Hakodate Station, the **Kanemori Red Brick Warehouse** is another of the city's most recognized tourist destinations. Built in 1909 they have been renovated to create an atmospheric shopping, dining and entertainment complex with historical charm. The warehouses contain about 50 restaurants and souvenir stores (generally 9.30 am–7 pm) and the authentic character of these waterfront buildings makes for a pleasant setting for shopping and browsing. If you want to partake in a quintessential Hakodate tourist experience, stop in for a Lucky Pierrot burger at one of the Hakodate-only chain's 17 eccentrically themed restaurants (most locations 10 am–12:30 am).

COBBLESTONE STREETS AND ARTISAN CULTURE
For an afternoon of exploration, a 25-minute walk, or 10 minute tram ride (¥210) from Hakodate Station will take you to the trendy hillside suburb of **Motomachi.** With its charming cobblestone streets, this area has a rising modern artisan culture, with plenty of boutique bakeries, soba restaurants and coffee houses doubling as gallery spaces for local art or handmade ceramic works. Energetic rickshaw runners collect tourists and trot their way through town wearing short shorts, jovial attitudes and beaming smiles.

The neighborhood climbs the hillside south of the bay and perched on its peak is the striking Byzantine-style **Russian Orthodox Church** (10 am–5 pm [10 am–4 pm Sat, 1–4 pm Sun], ¥200). Built in 1916, this distinctive building with its white walls and green roof—crowned by elaborate domed turrets—is one of the most significant buildings in the area and testament to international influence upon Hakodate's history.

Strolling the charming, store-lined streets to the north will take you to **Motomachi Park** and the **Old Public Hall of Hakodate Ward**. Built in 1910 as a community meeting place, this colorful blue-grey and yellow building holds a commanding view over the city, looking out and over the port. Its historical relevance and architectural significance make it one of Hakodate's most iconic buildings.

HOKKAIDO'S BEST NIGHT VIEW
Above the Motomachi area, rising 1,096 ft (334 m) over the city, **Mt Hakodate's** peak holds the premier view of the region and is said to have one of the world's best night views with Hakodate city cascading below like a sparkling sea of lights. Once a military fortress where artillery batteries and other war vestiges remain, this site is now a pilgrimage point for the 4-million-plus tourists visiting the city annually.

A ropeway operates (10 am–10 pm [10 am–9 pm in winter], ¥1,280 round trip,

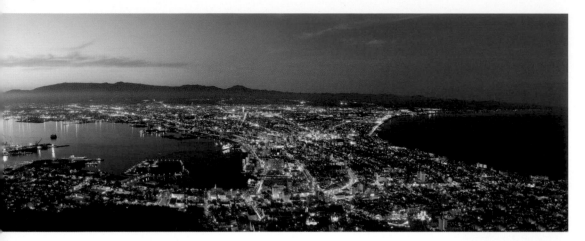

¥780 one way & children ¥640/¥390) from the car park below and ferries tourists in a constant stream to the top and back. Allow a couple of hours to settle in for the evening as the light of the day fades and the city's twinkling streetlights come to life. The perfect place to watch the sunset after a day exploring the city.

A STARBURST OF BLOSSOMS

A 10-minute tram ride from the main station and then another 10 minutes on foot, **Hakodate Fort (Goryokaku)** is the centerpiece of Hakodate's historical heritage. For 150 years the five-pointed, star-shaped fortress has formed the nucleus of the city as it expanded around it. Constructed by the Tokugawa shogunate—Japan's last feudal military government—it was designed to protect against Russian invasion. Before Hokkaido's full adoption into Japan's empire of islands, Goryokaku was the main fortress of the Tokugawa's short-lived Republic of Ezo.

The fort punctuates Hakodate's center and its location is pinned by the nearby 351-ft (107-m) tall **Goryokaku Tower** (9 am–6 pm [8 am–7 pm Oct to Apr], ¥900), which looks over the fort's remaining walls and the reconstructed historical government building within it. Spring is a great time to visit, when 1,000 cherry blossom (sakura) trees, planted in elegant gardens throughout the fortress, burst into life. Locals and visitors make the springtime pilgrimage in droves to sit under the trees and enjoy the beautiful pink and white blossoms, while barbecuing in earnest.

A DAY TRIP AROUND THE SOUTH

The perfect day trip from Hakodate is exploring the surrounding region via a loop around the **Kameda Peninsula**

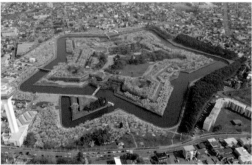

which extends north and east from the city and has several interesting stops along the way.

Just 18.6 miles/30 km (40 minutes' drive) north of Hakodate is **Lake Onuma,** surrounding the base of the ominous 3,710 ft (1,131 m) active volcano **Mt Komagatake**. This national park area is the ideal setting for a canoe exploration or picturesque walk around the 120 tiny islands floating in the lake, many linked by small bridges. In winter the large lake completely freezes, providing the perfect

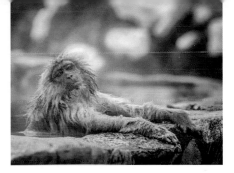

(8:30 am–6 pm [9 am–5 pm in winter], ¥300 adults, ¥200 children) where you will find an impressive natural geyser. Spurting water 49 ft (15 m) into the air at intervals of about every 10 minutes, this geyser is a local natural wonder and a rarity in Japan.

Left Exploring the beautiful national park area of Lake Onuma by canoe with Mt Komagatake in the distance.

Above One of a tribe of 100 monkeys enjoying a hot spring bath at the Hakodate Tropical Botanical Garden.

playground for ice fishing, snowmobiling and snow sledding.

Heading further east will bring you to the small onsen town of **Shikabe** (10.6 miles/17 km, 20 minutes' drive), home to the **Shikabe Kanketsusen Park**

Continuing the loop south and heading towards the **Cape Esan Lighthouse** (28 miles/45 km, 55 minutes' drive) you can keep driving (0.6 miles/1 km, 5 minutes) to discover one of Hokkaido's oceanside onsens, **Mizunashikaihin**

Hot Spring. Literally submerged at high tide, this little-known onsen offers short bathing periods when weather and tides permit and is certainly one of Hokkaido's most unique hot springs.

The Hokkaido Shinkansen: An Engineering Marvel

Trains that travel at almost 250 miles (400 km) per hour are impressive enough, but Japan has taken this engineering marvel to a new level with a tunnel under the ocean linking Hokkaido to Honshu by rail. Diving into the ocean at Aomori on the northern tip of Honshu, the Shinkansen makes landfall again at Hakodate, rising from the sea like a glistening oceanic serpent. The high-speed train links Tokyo to Hakodate in just four hours and two minutes. This stop is the first in a series of stations planned for Hokkaido in a wondrous national infrastructure plan that will eventually link Sapporo with the rest of Japan via high-speed rail. The Hakodate rail link was completed and opened in 2016 with plans to have Sapporo linked up by 2030. Much of the track heading north from Hakodate is planned to be underground due to Hokkaido's mountainous terrain and heavy winter snowfalls.

The Shinkansen is a smooth and relaxing way to travel, made even more enjoyable with a customary "bento" lunch box and a beer to satiate you while enjoying the scenery whipping by. Just don't blink or you'll miss it!

Hokkaido's West Coast: A Seafood Lover's Paradise

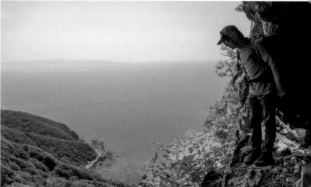

Below Looking back to the island of Okushiri from the climbing trail to Ota Shrine. Built in 1441 and nestled in a cave on a cliff face, this shrine is famed as being Japan's most dangerous.

On this strip of Hokkaido's remote western coastline you can literally see history decaying before your eyes as rustic, traditional fishing huts are slowly dismantled by the weather. Evidence of the evolution of life here is ever present, the old giving way to new, as trendy oyster restaurants take over old, abandoned fishing warehouses, restoring them and bringing new life to the area.

Stretching from the southern tip of Hokkaido to Iwanai, this is a much-forgotten corner of the island and a beautiful stretch of coast with an oceanside road connecting the small

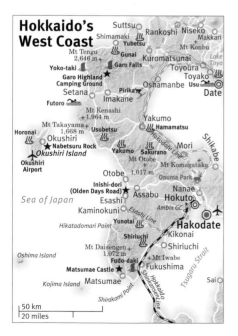

Hokkaido's West Coast

towns dotted along its shore. It makes for a great summer drive and is an ideal place to see the "real life" existence of Japanese fishing villages with local people living from the ocean the way they have done for decades.

Leaving Hakodate and heading west you will reach **Matsumae** (59 miles/ 95 km, 2 hours' drive) and the beautiful **Matsumae Castle** (see facing page) before continuing along a scenic coastal road to **Esashi** (40 miles/65 km, 1.25 hours' drive from Matsumae). A prosperous port town dating back to the 17th century, Esashi has a street aptly named **Inishi-dori (Olden Days Road)**. Extending east-west through the town, the street is lined with dozens of historical buildings and monuments showing what life was like in the time of the samurai.

During August every year the town holds the **Ubagami Grand Shrine Togyo Festival,** dating back some 370 years and an expression of gratitude for the

local fishermen's plentiful catches. Beautiful Japanese dolls sit atop 13 lavishly decorated floats and are carried through town to the chants of locals and the sound of traditional music.

Just slightly north of Esashi and marking approximately the half-way point along this coastline is **Okushiri Island**, which can be seen floating in the Sea of Japan 12.4 miles (20 km) off the coast. The island is accessible by ferry from Esashi and services run once daily, or twice during peak holiday seasons (¥2,860 economy seat, ¥5,740 first class, ¥15,000 for vehicles). While winters here are quiet, in summer it is a popular camping destination, with scenic coastal parklands and a relaxed seaside vibe. The island's coastal road is an easy way to take in the many points of interest, most notably **Nabetsuru**

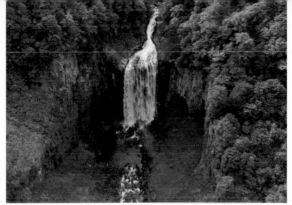

Rock, an intriguing stone arch rising from the water just south of the ferry terminal. The island is certainly worth an overnight detour from a Hokkaido camping road trip.

Back on the mainland and continuing north, the scenic road continues to wind its way through small villages as it heads for the town of **Shimamaki** (81 miles/ 130 km, 2.5 hours' drive from Esashi). A detour (12.4 miles/20 km, 30 minutes' drive, road closed in winter) into the mountains from here will bring you to

Garo Falls. Hokkaido's largest waterfall forming a 115-ft (35-m) wide, 230-ft (70-m) high curtain of water. Nominated as one of the 100 best waterfalls in Japan, it cascades into the Chihase River, which flows down from the highlands above Shimamaki. A legend remains to this day that a dragon guarded the local Matsumae clan's treasure here and "Dragon Water" is a naturally carbonated water that bubbles from a nearby spring. You can also find the **Garo Highland**

Camping Ground nearby.

Beyond Shimamaki the road holds its course north along the ocean's edge heading towards **Suttsu** (15.5 miles/ 25 km, 30 minutes' drive), a town famed for its oysters. Suttsu's coastline has a collection of beautiful fishing warehouses and buildings in varying states of decay and restoration, with trendy oyster shacks occupying old buildings made new again, breathing renewed life back into this seaside town.

Matsumae Castle

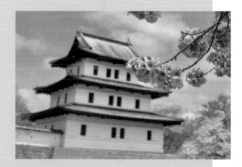

Located on the southern tip of Hokkaido, two hours' drive from Hakodate, **Matsumae Castle** (9 am–5 pm, closed mid-Dec to mid-Apr, ¥360) is Japan's northernmost castle and the only traditional Edo period-style castle in Hokkaido. Built in 1606 by Matsumae Yoshihiro, it was the chief residence of the Matsumae clan, built to defend the area—and by extension the whole of Japan—from the Ainu "barbarians" to the north. It once controlled all passage through Hokkaido and its importance as a site of surveillance is obvious when standing in the observatory looking all the way across the Tsugaru Strait to Honshu.

Today the castle and its grounds are a public park and is known as one of Hokkaido's premier cherry blossom-viewing sites, with over 10,000 trees coming into bloom around the castle and throughout the town. The castle's tower now serves as a museum where visitors can see traditional armor, artworks, clothing and other artefacts from the Edo period.

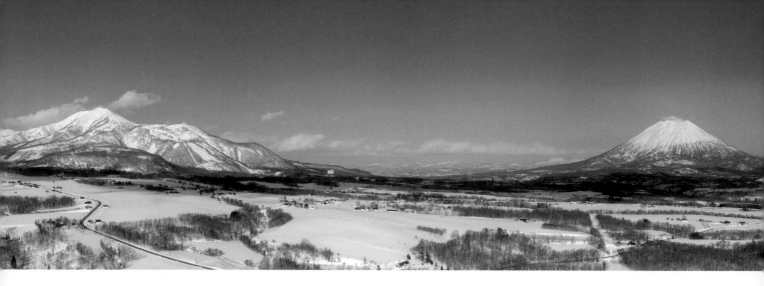

Niseko: Japan's Premier Year-Round Resort

Nestled in the mountains of the northern swathe of Southwest Hokkaido is the Niseko region—a vibrant nucleus of farming and tourism, famed for its fresh produce and globally renowned as a world-class ski destination with some of the most plentiful snowfalls on earth.

Heading west from Sapporo or New Chitose Airport, the Niseko area is around a two-hour (62 miles/100 km) journey by either road or rail. The region is centered around Mt Yotei—a 6,227 ft (1,898 m) stratovolcano rising above all else and with a striking resemblance to Mt Fuji. Fertile farm-lands fill the wide-open valleys, cut by mighty rivers fed by huge quantities of melted snow. The region is serviced by two main towns—**Kutchan**, with a population of around 20,000 people, and the smaller **Niseko** town

(approximately 5,000 people) about 15 minutes' drive further south.

Seasons here are a continuous transformation, from absolutely white winters to a thriving spring landscape of temperate days and cool nights, where the ferocity of winter is matched by a powerful desire to grow and flourish. Spring brings cherry blossoms and the fields come to life while the mountains

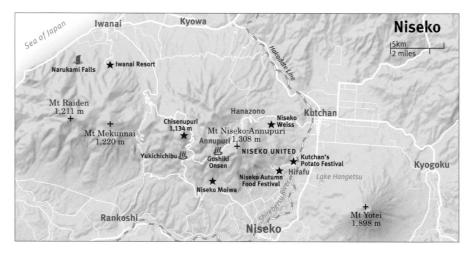

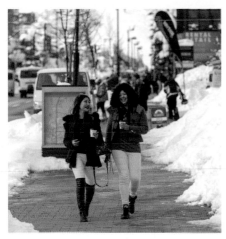

Left The vibrant streets of Hirafu village are the center of activity, shopping and nightlife in Niseko during winter months.

Right A soak in any one of the dozens of onsens in Niseko is a truly restorative and relaxing experience.

Far left Niseko's panoramic vista. From the ski fields of Mt Annupuri to the volcanic icon of Mt Yotei.

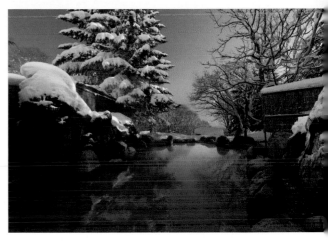

are flooded by a sea of green leaves.

Summers are very pleasant and the volcanic soil—combined with plentiful annual rainfall and warm, sunny days—makes for extraordinarily productive farming. Crisp autumns signal harvest season and are time for celebrations, while the colors of nature paint the mountainsides before retreating for the impending winter.

Niseko's mountains, rivers and lakes make it an outdoor adventure paradise. While skiing and snowboarding dominate the winters, the green season is alive with road cycling, mountain biking, hiking, camping, rafting and horse riding. Golf is a major feature of the area with many ski resorts becoming golf-centric in summer.

Right An adventure down the Shiribetsu river on a raft is a great way to experience the area from a different perspective.

The **Shirebetsu River**—the artery of life for the region and the primary catchment for the extensive mountain ranges—is one of the cleanest rivers in Japan and home to thriving fish populations, birdlife and river activity. Rafting, kayaking and SUP (stand-up paddle) boarding are popular through spring and summer with many tour operators centered around the ski resorts of Hirafu, Niseko Village, Hanazono and Annupuri. Fishing also brings many

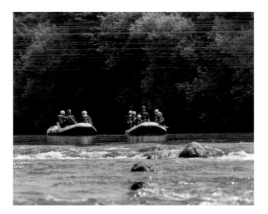

people to the river and its tributaries, seeking out salmon and trout seasonally.

Every season in Niseko brings a new reason to get outdoors and explore this picturesque corner of Hokkaido.

THE SKIERS' MECCA

Niseko is, without exaggeration, one of the snowiest places on earth and a mecca for skiers and snowboarders. Hokkaido's premier ski destination is **Niseko United,** a network of four large resorts each flanking the same mountain whose lift networks connect and share a common lift pass, the Niseko United All Mountain Pass (¥8,100 1-day adult pass, ¥4,900 for children). Mt Annupuri is home to the Hanazono, Grand Hirafu, Niseko Village and Annupuri resorts, each of which encompasses a different side of the mountain and link at the top thanks to its volcanic shape.

The buzzing hub of Niseko is **Hirafu,** a small village that has grown rapidly with the Hokkaido ski boom to be a

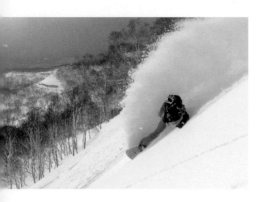

A snowboarder's paradise. Niseko is a winter wonderland of deep, dry powder snow.

Majestic Mt Yotei

There is no more iconic image of Hokkaido than **Mt Yotei**—the center of the Niseko region and most awe-inspiring and recognizable mountain on the island. Dubbed "Ezo Fuji" (Hokkaido's Mt Fuji), this beautiful, symmetrical volcano rises 6,227 ft (1,898 m) into the sky from the fields below and is visible from almost everywhere in the region.

Special to the original Ainu people and now to the residents of Niseko, with a seemingly gravitational pull, locals and visitors alike aspire to conquer its summit. In winter, hiking to the peak can reward skiers with the chance to ski perfect snow into the crater—the ultimate backcountry skiing experience.

There are hiking trails on each side of the mountain, the most established of these starting from Hangetsuko on the western side facing Hirafu, and from the trail head above the Yotei Nature Park on the southern Makkari side. The hike to the summit takes around five hours and is long and unforgiving, but offers breathtaking views over the entire region almost the whole way. This is a pilgrimage that is weather-dependent as the mountain can be hidden by clouds for days at a time.

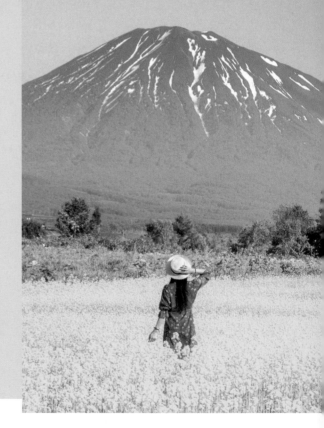

well-appointed mountain town with a large base of accommodation, from five-star modern ski chalets and hotels to traditional Japanese ryokans and ski lodges. This small village is home to many fantastic restaurants and seasonal tour operators year round.

Located alongside Mt Annupuri to the west (6.8 miles/11 km, 20 minutes' drive) is **Niseko Moiwa** (lifts operate 8 am–4 pm during winter, ¥4,500 1-day adult pass, ¥700 for children), a much smaller resort and popular with locals. Taking Route 66 into the mountains and about another 10 minutes' drive from Moiwa is **Chisenupuri**—an old single-lift resort now operating as a cat-ski-access backcountry resort. From here a road called the Niseko Panorama Line ends as snowfalls close it from November to May, and this terminus becomes the gateway to the Niseko area's extensive backcountry skiing terrain.

Kutchan's Food Festivals

As the epicenter of adventure in Hokkaido it seems strange that the annual celebration centers around a potato, albeit a skiing potato—Jagata-kun (potato boy)—and his cute snowboarding potato girlfriend, Jagako-chan. Well before skiing made Niseko world famous, Japan knew this region for its potatoes. And rightly so, as Kutchan has been producing Japan's finest potatoes for decades. Sampling the produce is the only way to be truly sure and there's no better opportunity than the Kutchan Jaga Matsuri (Potato Festival).

During the first weekend of August each year the town shuts down to celebrate the potato harvest and all things summer, with fireworks, drumming and a parade down the main street, food and drinks stalls lining the sidewalks. Jagata-kun is also a regular attendee of the Niseko Autumn Food Festival, held in the last week of September every year to celebrate harvest season and the region's abundant fresh local produce.

Right Iwanai is an oceanside town famed for offering some of Hokkaido's freshest and finest sushi and sashimi.

About 40 minutes' drive from Hirafu is the oceanside **Iwanai Resort,** with fantastic views out over the Sea of Japan. This is another resort, along with **Niseko Weiss,** whose lifts have long since been retired and is now purely a cat-ski resort. These eight resorts combine to create the largest ski resort area in Hokkaido.

From late October the mountains are capped by dustings of snow, eventually becoming thick blankets that bury the surrounding landscape all the way to sea level. The sheer quantity of snow that falls in this region is extraordinary, regularly exceeding 49 ft (15 m) annually. A unique weather phenomenon that sees cold winds from Russia drawing moisture from the Sea of Japan makes for exceptional, dry powder snow—the envy of ski resorts the world over.

The ski season commences in the last weeks of November and runs through till early-May when lift operations stop and summer reclaims the mountain peaks.

LAKE HANGETSU

Lake Hangetsu (Hangetsuko) is a small, picturesque caldera lake on the western side of the foothills of Mt Yotei—about a 10-minute drive from Hirafu or Kutchan.

Hangetsu translates to "half moon", so named for its crescent shape. The lake is popular for snowshoe tours in winter and hiking in summer and especially autumn, when the foliage becomes a vibrant tapestry of reds and yellows that reflect in the lake's surface, providing stunning photo opportunities. A walk around the edge of the lake takes around an hour and a path leads

Niseko's Culinary Smorgasbord

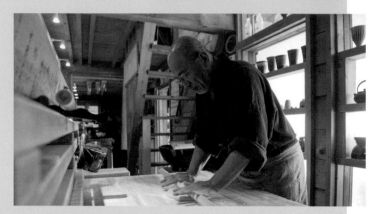

With astoundingly fertile soil and almost overwhelming amounts of fresh water, it's little wonder that the area has developed one of Hokkaido's most dynamic food scenes. Helped along by way of the annual international tourism injection in winter, Niseko is spoiled for choice, with everything from Michelin stars to local farmers' markets, and everything in between.

Almost all restaurants in this region have an innate connection to the local produce with many chefs frequenting their favorite local farms to personally hand-select the ingredients for their menus. Organic and healthy food choices are everywhere and it's all about eating local. Alongside Kutchan and Niseko's traditional *izakaya* restaurants is plenty of international cuisine, including French bakeries, Italian pizza joints and fusion restaurants that offer creative and usually exquisite Japanese interpretations of the world's favorite foods.

Many Niseko chefs will tell you the secret behind all of this is the water—plain and simple. Testament to this is the effort that restaurant owners go to to ensure the water they are using is the purest available. There are many natural springs in Niseko where the water bubbles to the surface after filtering through the bedrock of Mt Yotei and here you can see husband and wife teams with dozens of containers collecting water to take back for their restaurants.

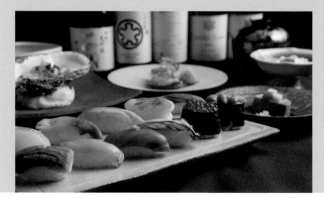

Embarking on a food safari in Niseko is perhaps best around harvest time, mid-September, when the freshest ingredients have just left the farms. This coincides with the **Niseko Autumn Food Festival** which runs over four days in the center of Hirafu. Many local restaurants celebrate the season with food stalls and the event is a great family affair, with fun activities and live music starting in the afternoons and running late into the evenings.

Left Exploring the Niseko backcountry. The mountains surrounding the main resorts areas of Niseko offer a vast playground of ski touring and exploration.

onsen leaves your skin feeling silky smooth, while the bite of sulfur in the air reminds you of the mineral-rich nature of the waters. Yukichichibu is a 30-minute, 12.4 miles (20 km) trip from Hirafu, with the final stage being Route 66 that snakes its way around the mountain and up into the Annupuri range.

Venturing 3 miles (5 km) past Yukichichibu and turning onto Route 58 will take you to **Goshiki Onsen** (10 am– 10 pm, ¥700 adults, ¥500 children). In summer this road is open and loops back to Kutchan, making a nice, scenic circuit around Niseko's central mountains. In winter (November to May) the road reaches a dead end at the onsen with snowfalls closing the passage. At 2,460 ft (750 m) elevation, deep into the Niseko mountain range, a collection of rugged, age-wearied wooden structures lies almost entirely buried for most of winter by months of relentless, wind-driven snowfall. In stark contrast, inside these buildings you will find the warmth of a centuries-old Japanese culture and sulfur-rich, turquoise hot spring baths.

down to its western edge, where its clean water attracts keen swimmers throughout the warmer months.

NISEKO'S HIDDEN HOT SPRINGS

The Niseko region is an onsen hot spot with more than 25 commercial bathhouses in operation, each drawing on a unique water source with distinctly different compositions. With the oldest onsen in the area dating back to 1899, this region has a long history as a destination for people seeking the healing benefits of the mineral-rich, volcanically heated waters.

From Hirafu, follow Route 343 and then Route 66 into the mountains and you will find two of the region's most iconic onsens.

The first of these is **Yukichichibu**

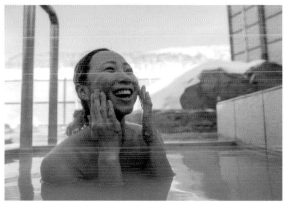

Above Enjoying a soak with a mud skin treatment in the colored pools of Yukichichibu onsen.

(10 am–8 pm, closed Tue, ¥500 adults, ¥300 children), which is characterized by colorful, sulfur-rich mud pools. This

The Shakotan Peninsula
Hokkaido's Wild Western Tip

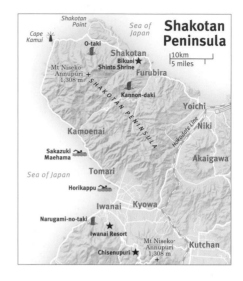

The Shakotan Peninsula is a wild area where the mountains morph into enormous and spectacular cliffs that plunge into the ocean. This rugged coastal peninsula juts out to the west between Otaru and Iwanai and offers fantastic coastal scenery with jagged cliff faces separating some beautiful sandy beaches. Driving the spectacular oceanside road is the best way to see the Shakotan Peninsula and a full loop departing from Niseko will take about three and a half hours (plus stops).

Iridescent blue and green water—more reminiscent of the Mediterranean than Japan—laps at the base of these stark rock faces. This area is a great summer destination with water activities and sea kayaking an excellent way to explore the coastline and caves tunnelling into it. There is a road which runs the entire way along the coastline, as well as a couple that traverse the breadth of the peninsula through the high mountain peaks.

In winter this is a cold and windy buttress of land, while in summer it feels more like a tropical ocean paradise. Visiting the most westerly tip of **Cape Kamui**—a thin, rocky ridgeline that writhes its way out into the ocean— provides possibly the most spectacular viewpoint, looking out to the west and down into the beautiful waters below.

There are a number of places to camp with an official campground near the end of the peninsula, as well as beautiful beachfront campgrounds right on the sand which, facing west, can provide some magical sunsets over the water.

The crystal-blue waters and green-fringed cliffs of the Shakotan Peninsula.

SEA KAYAKING

The turquoise blue of the Sea of Japan around the **Shakotan Peninsula** is one of the most beautiful summer sights to behold. Observing from the coast is one thing, but completely immersing yourself in amongst the rocky coastline is another thing altogether. Paddle alongside giant cliff faces, amongst rock columns, into caves and through thick fields of seaweed. A truly unique experience that may leave you wondering if you're in Japan or Southeast Asia. There are many tour options available leaving Hirafu daily throughout the summer.

Left Exploring the wild coastline of the Shakotan Peninsula by sea kayak is a great way to discover some hidden wonders, above and below the water.

The Shakotan Fire Festival

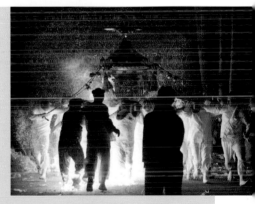

The Shakotan Fire Festival is a celebration of summer whose history stems back to farming and good fortune for the season's coming harvest and the safe return of the village's fishermen with plentiful catches.

Held in the first week of July every year, the local **Bikuni Shinto Shrine**'s celebration brings the tiny fishing town of Shakotan to life as its residents unite and the festival begins with a parade through the streets. Locals decorate floats (called *dashi*) and, over several days filled with music and endless chanting, cart their floats around town to the cheers of onlookers.

A fire demon (Tengu-no-Hikuguri) stalks through the town, followed by an entourage of priests and devotees carrying large and incredibly heavy timber *mikoshi* (portable Shinto shrines). It takes teams of participants to shoulder the weight of the *mikoshi*, as they move in unison towards the local temple. Villagers line the road to the temple where the fire demon dances and prances through burning piles of timber shavings, bursting through the flames with his singed hair and charred wooden sandals.

Finally he makes his charge to the temple and is followed by his devotees, still bearing the *mikoshi*. The contagious chants and singing accompany the procession all the way to its final destination before the festival heads back to the street for further dancing, singing and drinking around the decorated floats.

Rusutsu & Lake Toya: A Mountain Resort and Picture-Perfect Lake

The all-season resort area of Rusutsu and Lake Toya is a geographic yin and yang of impressive, snow covered volcanic peaks through winter and a stunning blue lake that serves as one of Hokkaido's most idyllic summer escapes. This area is a must-visit any time of year.

RUSUTSU

About a 30-minute drive southeast from Niseko is **Rusutsu** (lifts run 9 am–8 pm during winter, ¥5,900 1-day adult, ¥3,000 children), a large resort complex with a massive ski area, several golf courses and its very own amusement park. Rusutsu has a striking landscape with views across Lake Toya to the Pacific Ocean as well as to Mt Yotei, Mt Annupuri and over the long ridgeline of the adjacent peak of **Mt Shiribetsu**. Not to mention snow almost as consistent as the resorts of Niseko but with fewer people and some of Hokkaido's best lift-accessed tree skiing.

Rusutsu is a fantastic resort with two distinct sections. Around the hotel, convention center and amusement park is a small ski area on the flanks of Mt Shiribetsu. This ski area increases drastically in size with a ride on the connecting gondola to the opposing

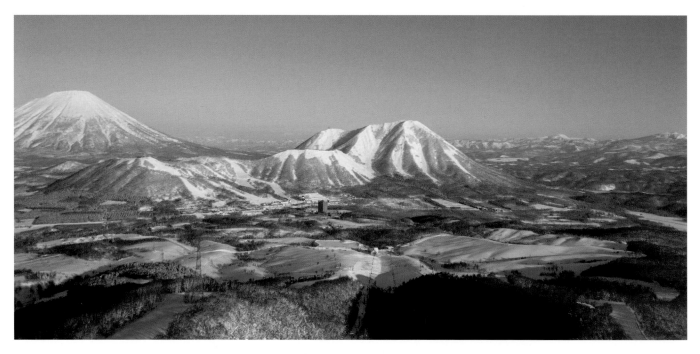

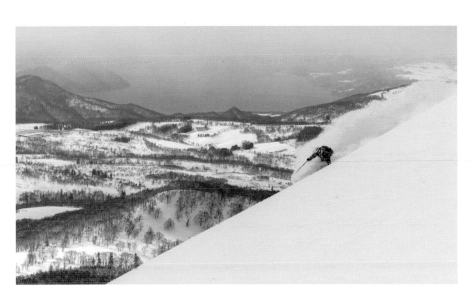

Above Perfect backcountry powder turns with views over Lake Toya.

Opposite Looking west from the large resort area of Rusutsu with Mt Shiribetsu at its center and Mt Yotei as a backdrop on the left.

side of the resort and another peak, **Mt Isola**, where a well laid-out lift system accesses one of the biggest single resort ski areas in Hokkaido.

Wrapping around the base of the **Rusutsu Resort** are two golf courses with a further two courses just a short drive away. The Tower Course is right next to the Westin Hotel and has some stunning holes, one offering a backdrop of the nearby theme park with its roller coasters and screaming children as your soundtrack. Other options are the adjoining Izumikawa Course and River and Wood Courses, accessed from

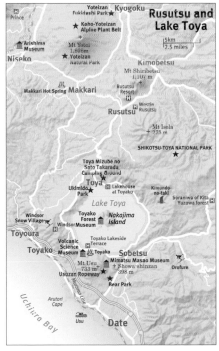

Above Teeing off towards Mt Shiribetsu on one of the area's many golf courses.

Kimobetsu (7 miles/11.5 km, 25 minutes' drive from Tower Course). Course open dates vary and may change due to snow conditions but are generally from late-April to early-November (check with hotel staff to confirm) and green fees start from ¥6,400 for 18 holes on a weekday.

LAKE TOYA

About 20 minutes' drive south from Rusutsu (or 50 minutes from Niseko), the tranquil paradise of **Lake Toya** (Toyako) is a huge volcanic crater lake with a quartet of islands at its center. The steam from the active volcano, **Mt Usu**, on its southern shore, provides a

Summer Camping at Lake Toya

Hokkaido's summer starts in earnest when camping and barbecues are the conversation topics preceding every weekend. With temperate summers, camping is one of the best ways to enjoy the natural gifts of the southwest region and Lake Toya is the premier choice. The pristine fresh water is fantastic for swimming, water sports and fishing and there are a multitude of campsites dotted around the shore, varying from well-appointed to secluded.

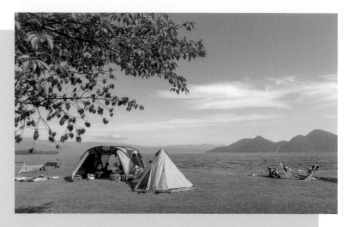

Well known as an exceptionally beautiful destination by Hokkaido locals, Lake Toya attracts both weekend boat enthusiasts from Sapporo and longer-stay guests traveling through Japan. Establishing a well-equipped campsite with a charcoal-fueled barbecue at its center is the perfect way to settle into life on the lakeside. Tents and tarpaulins strung up, nestled into the trees, with the lake lapping peacefully on the shoreline, this is a miniature oasis of tranquility and relaxation.

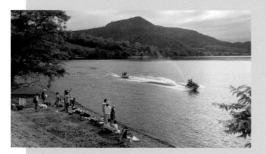

On the northern end of the lake is a small but absolute-waterfront campsite in the scenic parkland of **Ukimido Park**, within walking distance of restaurants and convenience stores, and on the eastern shore of the lake is the expansive **Toya Mizube no Sato Takarada Camping Ground**. Also very close to the water and with access for boats and jet skis, this is a larger campsite and suited to longer stays and boating enthusiasts.

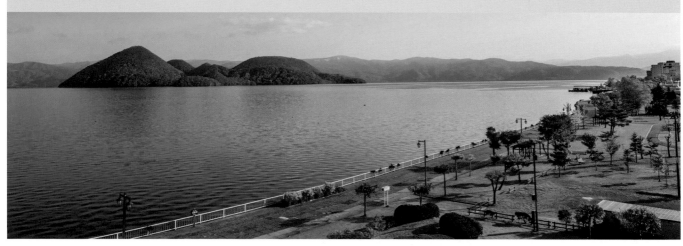

Left Cherry blossom trees lining the shore of Lake Toya with its islands enshrouded in mist.

From a second observation deck a short walk away there are views of the Pacific Ocean and Mt Usu's largest crater, which was formed in an eruption in 1977.

It's easy to access the ropeway station at Showa-shinzan, only a 10-minute drive or bus ride from the town center and it's open all year with hours staggered according to the season (9 am–4 pm Dec to Feb,[8:15 am–5:45 pm May to Sept], ¥1,600 adults, ¥800 children).

Left Exploring the walkways of the Usu Volcano Observatory from the top of the Usuzan Ropeway.

Below The Usuzan Ropeway rises to the volcanic rim of Mt Usu while looking back to Showa-shinzan, an actively smoking volcanic lava dome formed over the years 1943–1945 after a series of strong earthquakes.

constant and smoky reminder of the volatility of this seemingly sleepy and idyllic setting.

The lake is encircled by a road linking up the small towns, restaurants and onsens dotted around its perimeter. A circumnavigation of the lake by car takes around an hour but, accounting for the endless photo opportunities, it's a half-day adventure. Cycling around the lake is also a great way to spend the day, or just relax in one of the well-appointed campsites or onsen hotels with sensational views across the lake to its islands and beyond to the peak of Mt Yotei in the distance.

Mt Usu (Usu-zan) is one of Hokkaido's best-known and most unstable volcanoes, having erupted four times in the past 100 years, most recently in 2000. The **Usuzan Ropeway** brings you close to the volcano's summit where the upper station's observation deck offers panoramic views of Lake Toya and neighboring Showa-shinzan volcano.

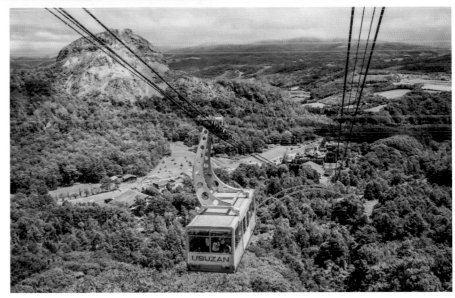

The South Coast & Noboribetsu: Gateway to Volcanic Hell

The Pacific Ocean coastline running from Tomakomai to Muroran (47 miles/75 km, just over an hour's drive) is a mix of industrial sea ports, beaches and concrete tetrapods that protect the coast against tsunamis and damaging waves. It's a drive that will take you through the "real" Hokkaido. Functional and forgotten, these towns are evidence of a time gone by with oceanside seafood restaurants that have closed their doors, remnants of a busier time that saw more traffic by ocean than air.

One of Hokkaido's most easily accessed areas, being just a short drive from New Chitose Airport (12.4 miles/20 km, 40 minutes' drive), this coastline is an easy adventure. **Tomakomai** is the seaside port you will first see from the air as you fly in and the first city you drive through heading southeast from Sapporo. A hub for petroleum and shipping, this city has a humming feel of no-nonsense industrialism, while still harboring a few of the nicer east

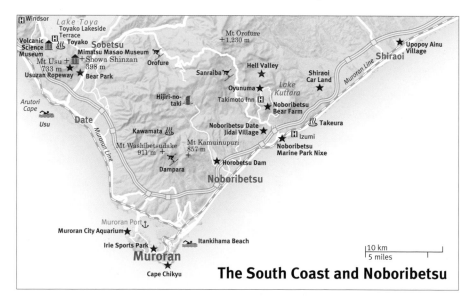

The South Coast and Noboribetsu

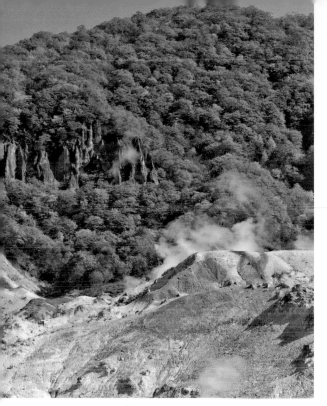

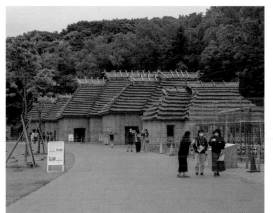

Left Hell Valley, the smoking volcanic heart of the Noboribetsu hot spring area. Walkways explore the valley and connect to several other hot mud pools and the Oyunuma Foot Bath.

Left Ainu tapestry is most recognizable for its powerful and symbolic designs placed on the traditional *attus* coats. These coats are woven from the inner bark of trees, split into fibrous strands then spun into threads. The designs are used in the belief they keep evil spirits at bay.

coast beaches close to Sapporo.

Venturing south (14 miles/23 km, 35 minutes' drive) will bring you to **Shiraoi**, where a cultural detour to the **Upopoy Ainu Village** is highly recommended. Originally, a traditional Ainu village was moved from the city's urban district in 1965 and restored on the shores of Lake Poroto. In 2020 a major redevelopment saw the opening of the new and very

modern museum with several additional facilities featuring cultural experiences, workshops and traditional performances. (Apr 1–Jul 16 & Aug 30–Oct 31, 9 am to 6 pm on weekdays, 9 am to 8 pm on weekends and national holidays. Jul 17–Aug 29, 9 am to 8 pm. Nov 1–Mar 31, 9 am to 5 pm. ¥1,200 adults, ¥600 high school student, children free)

Rolling south (22 miles/35 km, 25 minutes' drive) will bring you to **Noboribetsu** and arguably the most noteworthy stop on your venture south. Home to **Hell Valley**, volcanic lakes, and an onsen town, this area is worth a stop

for some sightseeing and relaxation—onsen style. Guarded by demons, this aptly named valley is a stark landscape of sulfuric gasses and mineral-rich hot pools with a terraced valley of hotels and ryokans plugged directly into the healing waters.

The **Noboribetsu Date Jidai Village** (or Ninja Village) is a historically themed culture park, perfect for a family day trip. Edo-period building and streets have been fully recreated and give the

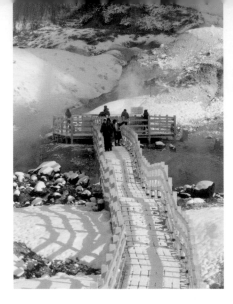

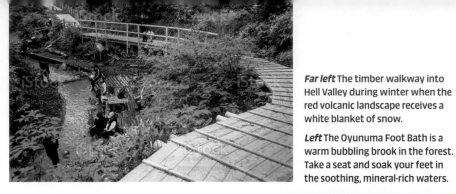

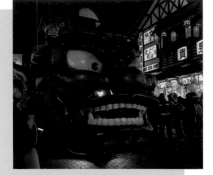

authentic feel of stepping back in time to ancient Japan, complete with ninja action shows and other fun activities. (Summer 9 am–5 pm / Winter 9 am–4 pm, ¥1,600 adults, ¥1,200 children).

A 25-minute hike or five-minute drive beyond the onsen town will take you to **Oyunuma,** a colorful mud pool, nourished by volcanic activity, and further on to **Lake Kuttara** (an hour's hike or 8-minute drive). The lake is officially home to some of Japan's (and arguably the world's) purest water, after that of Lake Mashu in Eastern Hokkaido. It owes its pristine qualities to its waters being captured rainwater and snow rather than river runoff.

MURORAN

Leapfrogging south along a mixed coastline of nice-enough beaches, river mouths, and the ever-present tetrapods will deposit you in **Muroran** (18.6 miles/ 30 km, 40 minutes' drive). Impressive for

The Noboribetsu Hell Festival

Once a year the gateway to hell opens and the demons of Hell Valley come out for a procession down the main street of this onsen town, led by the king of the demons, King Enma. This is a festival of costumes, food and good times, embraced enthusiastically by the locals. Lanterns line the streets, which are filled with shops and stalls selling food, drinks and the promise of merriment over the last weekend of August every year. The highlight of the event is the procession of the demon gods on their *mikoshi* (portable shrines), carried by locals to the cheers and shouts of festival goers lining the sides of the road.

Like every summer *matsuri*, fireworks are an essential ingredient and the perfect backdrop for the final procession of the demon king upon his mighty float, dragged by scores of locals on long ropes and breathing smoke from

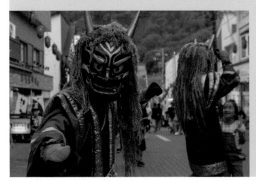

the demonic head of his chariot. The festival's theme is well suited to the town itself, nestled in a valley of steaming sulfuric volcanic vents, it certainly has the feeling of a crack in the earth that has spawned the horrors of the underworld.

Right Storm clouds illuminate the night sky behind the Hakucho Bridge, which spans Muroran's harbor.

Bottom left The Pacific white sided dolphin are the friendly Muroran locals. These, and many other species, call the fertile waters around the port town home.

Bottom right Itankihama Beach, a picturesque beach where the sand is said to sing as you walk on it.

its industrial magnitude, Muroran is a seaside alcove of big industry, where factories and shipping yards own the waterfront.

What is not obvious from first impressions is that Muroran is an important harbor for many large species of ocean mammals. Orca, whales, fur seals and 10 species of dolphin are common here and congregate in great numbers. Through spring, summer and autumn, large pods of Pacific white-sided dolphin—often 400 strong—can

be seen feeding in these waters. Boat tours operate from June to August and offer close encounters with these friendly locals who will often swim right alongside (Star Marine KK runs 2.5-hour cruises twice daily with a 98% encounter success rate, ¥6,000 for adults, ¥3,000 for children).

A drive up to the lighthouse on **Cape Chikyu** (1.9 miles/3 km, 10 minutes' drive from the center of town) provides brilliant views towards the Japanese mainland from the jagged cliff-tops. This small stretch of coastline along the cape is 8 miles (13 km) of rock and cliff face but hides a little-known secret— **Itankihama Beach** which is also well worth a visit on a nice day.

Central & Northern Hokkaido: Into the Vast Island Heartland

Leaving the bright lights of Sapporo behind and heading north will take you into a land of unprecedented beauty; of mountains, rivers and lakes, and oceans with volcanic islands rising from their depths. The highways whisk you away from the residential surrounds of Sapporo and the scenery changes quickly—flat at first, the terrain rises as the middle of the island gains altitude and soars high above the plains below.

This vast, richly varied region spans from Erimo in the south, all the way to Wakkanai, Hokkaido's northern tip. It includes the Hidaka Mountains—a volcanic spine of mountains running 93 miles (150 km) from Mt Sahoro or Karikachi Pass, in the center of the island, to the sea at this region's southernmost point, Cape Erimo. It encompasses vast forests in the north and the rural area of Obihiro, a huge area of flat and fertile farmlands in the east.

Punctuating the middle of this area and the island itself is the Daisetsuzan Mountain Range, the largest mountain group in Hokkaido and home to the Daisetsuzan National Park—Japan's largest natural reserve. Here you will find the island's highest peaks with 16 reaching above 6,562 ft (2,000 m)—the tallest of them, Asahidake, at 7,516 ft (2,291 m) is the pinnacle of Hokkaido. The first to see the winter and last to bid it farewell, this heartland is characterized by a white panorama of mountain peaks dominating the skyline for much of the year.

On the eastern side of this spine of mountains, the Furano Valley forges north to Asahikawa, the largest city in this region and the second largest in Hokkaido. Snow brings winter activity to the mountains and spring releases the famed lavender fields that have been drawing large crowds of domestic and international visitors for decades. The area around Furano is beautiful and the charming patchwork fields are an ever-changing landscape to enjoy.

Beyond here and occupying the very tip of the northern Hokkaido mainland, Wakkanai is a small city with enormous geographic significance as Japan's most northerly outpost. Wakkanai looks out over the Sea of Okhotsk to Russia and is the guardian of the gateway to Hokkaido's Rishiri and Rebun islands.

The beautiful rolling hills of the Furano and Biei flower farms are a wonder of color through the summer months. A fertile valley, set against a backdrop of the snowcapped peaks of the Daisetsuzan Mountain Range.

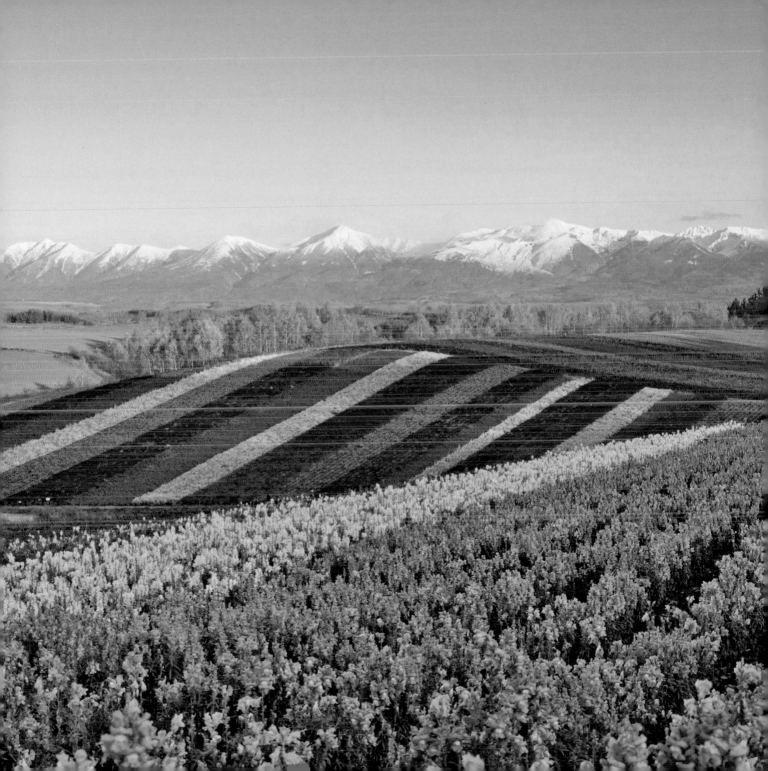

A Tour of Asahikawa:
Hokkaido's Second Largest City

Marking the geographic center of Hokkaido is Asahikawa, Hokkaido's second largest city. Significantly smaller in population than Sapporo, with around 350,000 residents, Asahikawa is nevertheless an important business center and a charming city to visit year round. Probably most famous in Japan for its signature ramen noodles, Asahikawa holds the record for the coldest temperature ever recorded in Japan, an inconceivable -41.8° F (-41° C).

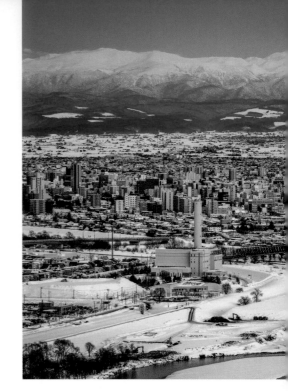

Sitting alongside the banks of the Ishikari River, Hokkaido's longest river and the third longest in Japan, Asahikawa is a welcoming city with a vibrant summer to balance the foreboding winters it endures. It is only 81 miles (130 km) from Sapporo and can be easily accessed by train, bus or car but also has its own airport catering to domestic visitors as well as international flights from Taiwan, Korea and China.

Right Asahikawa is nestled in the heart of Hokkaido. The second largest city on the island, it is warm and temperate in summer, and cold and snowy in winter. The town is flanked by the Daisetsuzan Mountain Range to the east and dissected by the snaking Ishikari River.

STROLLING THE CITY CENTER
A good place to start your exploration of the city is at **Asahikawa Station**. Flanked by the river to its south, the city center and main shopping and nightlife precinct extends north. There are several multi-level shopping malls located alongside the station, marking the entrance to **Heiwa Shopping Street (Heiwa-dori)**, Asahikawa's pedestrian-only, shop-lined street running some 16 blocks north from the station.

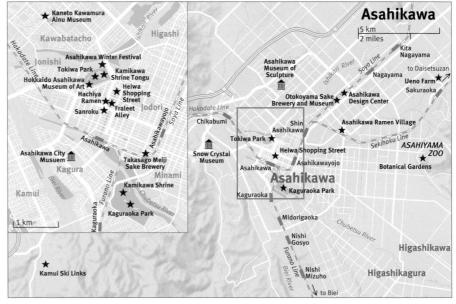

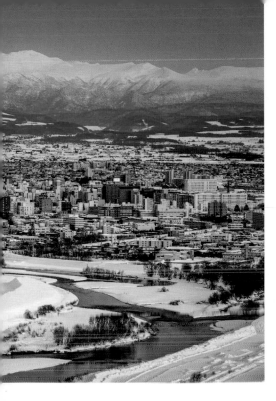

An energetic nightlife hums through the city center of an evening and laughter and activity bubble from within *izakayas* and bars filling streets that branch out from this thoroughfare. The main nightlife hub is the **Sanroku entertainment district**, boasting some 1,300 bars and restaurants. Mid-way along Heiwa Shopping Street (seven blocks), turn west, walk two blocks and you'll recognize Sanroku by the neon lights and streets lined with bars, karaoke pubs and restaurants.

Just a short, 164 ft (50 m) walk from Heiwa-dori, another fun area to check out is **Fraleet Alley**, a tiny, old, authentic alley whose moody disposition is set by the soft glow of yellow lanterns, and home to the famous **Hachiya Ramen** restaurant dating back to 1947. The alley is a collection of bars and restaurants with sliding doors that give it a classic Japanese atmosphere.

A 1,640 ft/500 m (7-minute) walk west

Right and below The fairytale-like Snow Crystal Museum in Asahikawa was built to represent the image of the beautiful, perfectly formed snow crystals that fall on Japan's Daisetsuzan Mountain Range every winter.

A Skiing Day Trip

If your visit to Asahikawa coincides with the winter ski season then a day trip to **Kamui Ski Links** is highly recommended. The largest resort in the Asahikawa area but off the beaten track, it manages to escape the ski tourist crowds. 12 miles (20 km) southwest of the city and 30 minutes' drive from the city center, the resort is open every day from December to March (9 am–4:30 pm, adult 1-day pass ¥3,100, children [6–12] ¥1,500).

If you are making a trip to Kamui Ski Links, an interesting stop along the way is the **Snow Crystal Museum**. Set in a small European-style castle complete with turrets, this quaint and quiet museum is dedicated entirely to snowflakes. The fairytale continues inside with grand chandeliers, a circular staircase and corridor of ice encased behind glass. The Snow Crystal Museum is about halfway (10 miles/16 km, 20 minutes' drive) between Kamui Ski Links and the city center.

from the northern end of Heiwa-dori is **Tokiwa Park,** home to the **Hokkaido Asahikawa Museum of Art** (9:30 am–5 pm, closed Mon, ¥170) and **Kamikawa Shrine Tongu**. The northern side of the park is flanked by the Ishikari River and the riverbank provides the main site for the **Asahikawa Winter Festival**—held in the first week of February, it is the second largest in Hokkaido after the Sapporo Snow Festival. It extends from the park into the city, with ice sculptures also occupying Heiwa-dori.

Northwest of the city (about 1.5 miles/2.5 km, 10 minutes' drive) you will find the **Kaneto Kawamura Ainu Museum** (9 am–5 pm Sept to Jun [9 am–6 pm Jul to Aug], ¥500), the oldest Ainu museum in Hokkaido, established in 1916. This

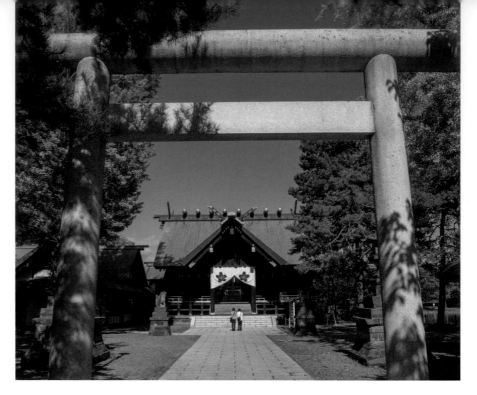

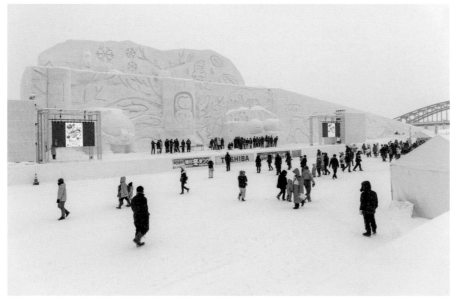

quaint collection of buildings exhibits tools from Ainu daily life and runs programs that include performances of the *mukkuri* (a folk musical instrument), classical dance and embroidery workshops (bookings required).

Asahikawa Museum of Sculpture (9 am–5 pm, closed Mon, ¥300) is also

Above Kamikawa Shrine is one of Asahikawa's most cherished sites. Nestled on a hilltop within the natural beauty of Kaguraoka Park, this is one of Asahikawa's most peaceful places, perfect for reflection, relaxation and meditation.

Left The Asahikawa Winter Festival has a different theme every year, but giant ice sculptures are guaranteed. The event once made it into the Guinness Book of World Records for having the largest snow structure ever made, a towering replica of a Korean fortress built in 1994.

Far left Once an officer's social club for the Imperial Japanese Army, the Asahikawa Museum of Sculpture is housed in a beautifully restored historical building dating back to 1902.

Left The Asahikawa City Museum where you can learn about the Ainu heritage of the region as well as the natural history, climate and ecosystems of Asahikawa and the surrounding area.

located in this corner of the city and is a 1.9 mile (3 km), 15-minute drive north of the Ainu Museum. The beautiful building, dating back to 1902, is designated as an Important Cultural Property of Japan and in 1994 it was opened as a museum in honor of local sculptor Teijiro Nakahara.

SOUTH OF THE STATION

A short walk (15-minutes) across the river and south of the station is the **Asahikawa City Museum** (9 am–5 pm, closed some Mon, ¥300 adults, children under 12 free) with two floors of permanent exhibits centered around the relationship between the nature and people of northern Japan, and Ainu artefacts and culture.

A 20-minute walk (0.9 miles/1.5 km) from here, heading east, will take you through the city's edge to **Kaguraoka Park**, home to the **Botanical Gardens** center and the beautiful **Kamikawa Shrine**. This hilltop parkland is a picturesque setting for Asahikawa's most impressive temple with a peaceful

Asahikawa's Famous Soy Ramen

Hokkaido folk take pride in their ramen, perhaps more so than any of the other regions of Japan as it's truly a winter food—and Hokkaido is truly winter's homeland. From the center of the island comes the famous Asahikawa ramen, whose tantalizing flavors bring taste bud-driven tourists from Japan and wider Asia.

While Sapporo ramen broth is known for its miso-base and Hakodate for a salt-base, Asahikawa is known for its distinctive brand of savory, umami-rich shoyu (soy sauce) flavor. The broth of Asahikawa ramen is also known for having a thin layer of oil on top of the soup, said to be a special technique that keeps the broth piping hot. This local ramen generally has thin, hard and wavy noodles—a unique characteristic. The iconic nature of ramen here means any visit to the city will ensure you are never far from a ramen restaurant, each with its own special character.

Higashikawa: Hokkaido's Hippest Town

About 9 miles (15 km) southeast of Asahikawa is the small town of Higashikawa. Unassuming and surrounded by farmlands at the base of the mountains, there is little to indicate the thriving artisanal culture of Higashikawa. This quaint town is a small hub of coffee shops, restaurants, galleries and funky stores, defying the banality of its rural surroundings.

This small, sleepy village now has a vibrant pulse of underground design and outdoor culture. The final stop before ascending into the mountains, the town is attracting a new wave of youthful artisans, keen to move away from the city to be closer to nature, carving out an existence with clever retail and delicious boutique restaurants and cafés.

On an exploratory trip of the area, Higashikawa is a great place to spend a relaxed afternoon, wandering the streets and finding a nice coffee shop, lunch or dinner option before venturing on. There are good vibes all around and a chat with any of the locals usually provides insight into modern life in regional Hokkaido.

Top Higashikawa has many small owner-operator style cafés and restaurants, all with an intentional no-frills, organic vibe and quality food.

Left Lots of old warehouses have been converted into trendy coffee shops and lunch restaurants. This is Wednesday Cafe and Bake, located on the outskirts of town heading towards Asahidake.

Above There are plenty of coffee shops to stop and try as you're passing through, but maybe not enough time to try them all! Roaster Coaster, pictured here, is just one of several in the center of town.

feeling emanating throughout the parklands from the temple at its peak.

From the park you can walk north, through riverside parklands (about 15-minutes, 0.8 miles/1.3 km) to the **Takasago Meiji Sake Brewery** (9 am– 5 pm, free). Inside this historic building (constructed in 1909) you can see the brewing process and sample some "Kokushi-muso", a delicious dry sake the brewery is renowned for.

A LUNCHTIME EXCURSION

An afternoon exploring the northeast side of the city could start with lunch at the **Asahikawa Ramen Village**, a collection of famous ramen restaurants stacked alongside each other in a kind of ramen-lover's para-dise. Located about 9 miles/ 15 km (five-minute car or taxi ride) from Takasago Brewery, it's wise to head here early as tourist buses can often cause the restaurants to become quite busy around lunchtime.

About 1 mile (2 km) west of the ramen village—and walkable (30 min-utes) once you have filled up on ramen—is the **Otokoyama Sake Brewery and Museum** (9 am–5 pm) the second notable sake brewery in the city. Like Takasago, brewery entry is free and there is a museum exhibiting some of the old tools used in sake brewing.

Just another 2,625 ft/800 m (10 min-utes' walk) north is the **Asahikawa Design Center** (9 am–5 pm, free), home to permanent booths for around 30 Asahikawa-area furniture and craft makers and where you can shop for furniture and hand-crafted souvenirs,

or you can just browse the works seeking design inspiration.

Ueno Farm (10 am–5 pm late Apr to mid-Oct, closed Mon, ¥800 adults, children under 12 free) is nestled in the city's outskirts about a 15-minute drive (5 miles/8 km) from the Asahikawa Design Center. This quaint farm boasts an elaborate English-style garden created by garden designer Sayuki Ueno—with over 2,000 types of flowering plants and a gift shop and café housed in the old farm buildings at the garden's entrance.

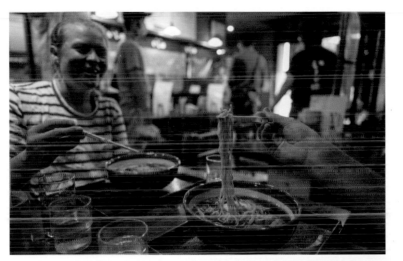

Above Asahikawa is famed for soy-based ramen and there's no better place to sample the multiple variations than Asahikawa Ramen Village.

Right Takasago Meiji Sake Brewery is housed in a traditional-style building and has a gift shop with sake tasting and a wide variety of sake available to purchase.

Daisetsuzan: The Volcanic Playground of the Gods

The Daisetsuzan is an enormous expanse of active volcanic mountains running down the middle of Hokkaido, like the protruding spine of a giant sleeping dragon. Vast forests roll in rhythmic repetition over ridge lines and valleys as they climb the lower steps towards the endless alpine expanse, while smoke billows constantly from open sulfur fumaroles escaping from the island's highest peaks.

Named "Kamui Mintara" (Playground of the Gods) by the indigenous Ainu, this area of Hokkaido rises above everything else and lies 19 miles (30 km) southeast of Asahikawa. The **Daisetsuzan National Park** encompass the heart of Hokkaido covering some 875 mi² (2,267 km²), making it the largest national park in Japan. This enormous expanse is almost entirely comprised of mountains and pristine wilderness.

In the northern part of this natural wilderness you will find **Kurodake** (Black Mountain), a piercing triangle of rock rising to 6,509 ft (1,984 m), with Sounkyo Onsen at its base. To its southwest, dominating the enormous Daisetsuzan range and continually venting steam and smoke into the sky above it is **Asahidake**, (7,516 ft/2,291 m) the crowning peak in Hokkaido. Further south this wilderness area encompasses **Furanodake** and the ever-smoking **Tokachidake** with more mountains stretching east and

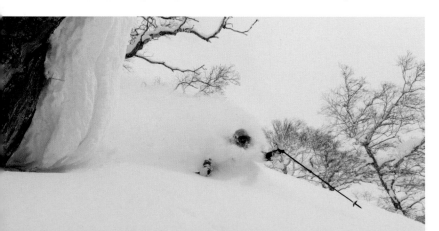

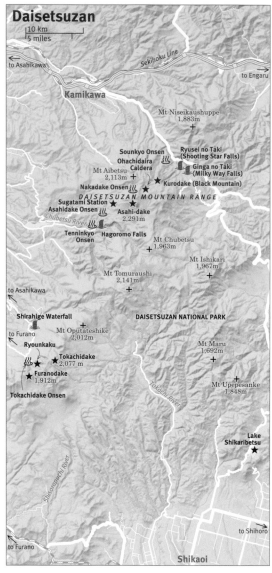

Left The higher-altitude peaks of the Daisetsuzan Mountain Range receive huge quantities of snowfall, and are renowned among skiers for offering some of the world's deepest and driest powder snow.

The Roof of Hokkaido:
Mt Asahidake to Mt Kurodake

Beyond the peak of Asahidake extends a huge alpine plain encompassing the largest volcanic crater in Hokkaido—the 1.2-mile (2-km) wide **Ohachidaira Caldera**—with Mt Kurodake beyond its northern rim. With ropeway access at either end, a hiking traverse of this alpine highland is a challenging adventure that can be done in a day, or as a return loop with an overnight camping stop at one of two designated campsites.

Starting out from the **Sugatami Station**, at the top of the Asahidake Ropeway, it is a physical 2.5-hour hike to the summit of Asahidake but rewarding when standing on the highest point of Hokkaido, enjoying panoramic vistas of all of Daisetsuzan.

Descending from the peak down past the Ura-asahi designated camping area (no facilities) the trail leads east to Mamiyadake, from where you can take the northern or southern route around the rim of the crater with equally spectacular views on either side. Following the northern route towards Kurodake you will reach the **Kurodake Refuge Hut** offering basic hiking support in summer and emergency shelter in winter. There is a designated camping area alongside with space for around 20 tents (¥500/night).

While the hut keepers are in residence (last weekend of June till the last weekend of September) overnight stays in the hut are permitted (¥2,000). Alternatively, from here it's a short hike to the summit of Kurodake and down to the chairlift and ropeway to **Sounkyo Onsen** where you can stay overnight in the comfort of an onsen hotel. Be sure to check the time for the last returning ropeway.

Returning, take the southern route which will give you the option to detour to **Nakadake Onsen** where you can soak your feet and break up the hike with a lunch stop. You can even boil an egg in the hottest part of the water, closest to its source. From here it's a lower gradient return to Sugatami Station, completing the loop.

Above Seasons collide as the first snow of winter falls on the peak of Asahidake, meeting the autumn leaves briefly before the transformation to a frozen landscape takes place.

Left Welcoming sunrise from the peak of Asahidake before venturing into the high-altitude plateau of the roof of Hokkaido.

south from here.

The Daisetsuzan mountains are the birthplace of the Ishikari and Tokachi rivers, which are the lifeblood of much of Hokkaido. The Tokachi River drains the southeastern side of this mountain expanse and feeds the highly fertile farming regions of Kamisahoro and Obihiro to the southeast, extending as far as the Pacific Ocean where the river meets the sea.

At 166.5 miles (268 km) in length, the Ishikari River is Hokkaido's longest river, the third longest in Japan, and second largest in volume. It wraps itself almost completely around this giant mountain expanse, beginning from Mount Ishikari in the east and encompassing the northern reaches of the Daisetsuzan, then flows south through Asahikawa and Sapporo before reaching the Sea of Japan.

The national park is a haven for wildlife with large populations of Ezo shika (Hokkaido deer), Ezo red foxes and brown bears, along with many rare

Above Several high altitude ponds are linked together by walking trails running from the Sugatami Ropeway station. These ponds receive the first snow of winter and are the last to recede from their frozen state as summer arrives.

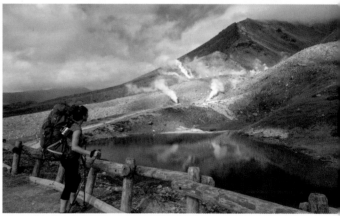

Right Looking across Sugatami pond to the smoking sulfur fumaroles of Mt Asahidake.

species of birds and enormously diverse vegetation. For outdoor enthusiasts Daisetsuzan is something of a wildly-oversized playground with so much to offer, but with a very fragile temperament—prone to wild and quickly-changing weather. The park contains many great hiking options, from day hikes to seven-day expeditions, such as the Great Traverse which crosses north to south from either Kurodake or

Asahidake to Furanodake, overnighting in alpine huts and campsites to break up the almost 50 miles (80 km) trek.

A great way to explore the park is a trip to **Asahidake Onsen**, about an hour's drive from Asahikawa. This small hot spring resort consisting of a handful of onsen hotels and lodges, nestled around the base of the ropeway (3,609 ft/1,100 m), offers hikers and sightseers access to the Sugatami

The Sounkyo Festivals of Fire & Ice

From late-January to mid-March each year, the **Sounkyo Ice Waterfall Festival** transforms the hot spring resort of Sounyko Onsen into an impressive ice village with castle-like structures and multi-level buildings providing a maze of ice chambers and staircases to explore, along with an ice shrine, ice slides for tubing and an ice bar serving warm sake. On weekends and public holidays there is also the option to try ice climbing on a man-made wall of ice (10 am–3 pm, ¥3,500 including equipment rentals), while a stage hosts *taiko* drum performances, traditional Ainu dances, mochi catching, and even ice weddings. Evenings are a great time to visit when the colorful lighting provides an otherworldly feel, with fireworks closing the festival (2 pm–10 pm, ¥300 entrance fee).

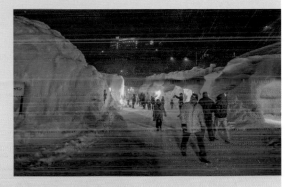

Drawing on Ainu tradition and spanning a two-week period from late-July to mid-August, the **Sounkyo Onsen Gorge Fire Festival** is held to honor and pray to the gods of fire and mountains. Along with nightly fireworks, the festival's primary celebration centers around traditional Ainu fire, dancing and drums and a re-enactment of the ancient Owl Ritual, intended to emulate the movements of nature and help the Ainu commune with the *kamui*—the divine beings that inhabit the earth as bears, foxes or owls.

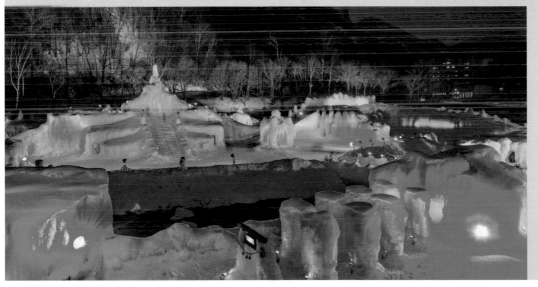

Above and left The illuminated ice structures of the festival are linked together creating an otherworldly feeling as you wander through the frozen, life-size ice complex.

Station (5,249 ft/1,600 m). From here there is the option to hike to the top of Asahidake (about 2.5 hours) or take a more relaxed walk, like the 60-minute circular trail around the ropeway's upper station, which winds between several alpine ponds and sulfurous fumarole vents.

Summer hiking season runs from June through September, while in winter the ropeway offers access for skiers and snowboarders. The ropeway operation is weather dependent and varies between 6 am and 6 pm during summer and 9 am and 4 pm during winter, departing every 15–20 minutes, and is closed from

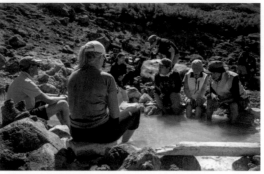

Left After a long day hiking, the soothing waters of Nakadake Onsen are a welcome reprieve for tired feet.

Below left The spectacular twin waterfalls of Ginga no Taki and Ryusei no Taki spilling down the rock face through Hokkaido's autumn colors.

Bottom The Ezo red squirrel is a subspecies found only in Hokkaido. Rather than hibernating in winter, these squirrels grow an impressive winter pelage making them very fluffy from their tail to the tips of their ears. Keep an eye out for their more elusive counterpart, the Ezo momonga or Japanese dwarf flying squirrel. Also found only in Hokkaido, they are extraordinarily cute and can glide as far as 328 ft (100 m) between trees.

mid-November to early December (¥2,900 round-trip June to mid-Oct [¥1,800 mid-Oct to May]).

Below Asahidake Onsen is **Tenninkyo Onsen,** where a short (1,969 ft/600 m) walk from the hot-spring village will take you to the spectacular **Hagoromo Falls,** cascading 886 ft (270 m) down a tiered stone face. If driving to Asahi-dake, this is a quick detour from where the mountain road begins to climb. Take the right-hand fork and follow this

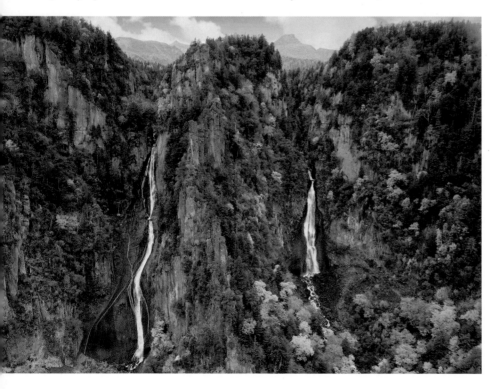

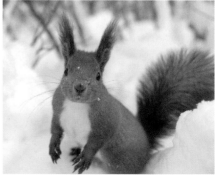

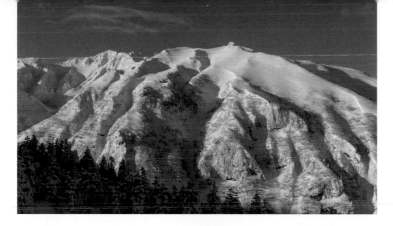

Above The menacing and wild northern face of Furanodake.

Right In winter, a small collection of igloos are constructed on the frozen Lake Shikaribetsu to create a small village complete with an ice bar and onsen.

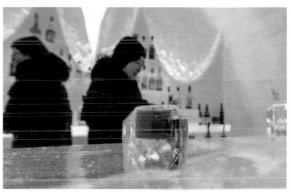

car from Furano (around 20.5 miles/ 33 km, 50 minutes from the city center), you will discover the powerful volcanic area of Tokachidake, with its smoking volcanic peak and natural hot springs, and neighboring Furanodake, a striking and violent-looking mountain with steep ridge lines plunging into the gorge below.

Perched here in a valley between these two peaks, at around 4,199 ft (1,280 m), you will find **Tokachidake Onsen**—four hot spring ryokan (traditional Japanese inns that typically feature tatami-matted rooms, communal baths) climbing the mountain road; the furthest of which (**Ryounkaku**) create the valley and looks directly into the Tokachidake mountains. The onsen in this historical lodging is also open to non-staying guests and is well known for its majestic outlook and the deep brown color of its mineral-rich waters.

On the eastern side of Daisetsuzan, above the Kamishihoro area, **Lake Shikaribetsu** is the highest elevation lake in Hokkaido (2,638 ft/804 m) and the longest-freezing lake in Japan; usually from the end of January to end of March, when it hosts the local winter festival, the **Lake Shikaribetsu Kotan**. The festival takes place literally on the frozen lake, where a small, man-made ice village appears with igloo lodges, a bar, and even an open-air onsen bath. In summer the lake is a tranquil paradise and renowned for its exceptionally clear waters.

road for 5 miles/8 km (10 minutes) to Tenninkyo Onsen, a small collection of seemingly forgotten hot-spring hotels and lodges.

A second option for an initial exploration of the park is to start from **Sounkyo Onsen**, another onsen town slightly north from Asahidake (but a two-hour drive around the mountain). Sounkyo Onsen is lodged in the giant crevasse of Sounkyo Gorge with 328-ft (100-m) high cliff faces rising on either side. The town is a more touristy hot spring resort with large hotels and a ropeway lifting visitors from the base of the gorge to an altitude of 5,249 ft (1,600 m),

from where it is a relatively short hike (one hour) to the summit of Kurodake.

About 1.9 miles (3 km) east of the village center and further up the valley are the stunning twin waterfalls of **Ginga no Taki (Milky Way Falls)** and **Ryusei no Taki (Shooting Star Falls)**. These falls plunge some 328 ft (100 m) down the cliffside with a huge menhir of rock protruding between them. Both falls are visible from a large parking lot across the river but for better views there is a path leading to a small observation deck (15–20 minutes' walk).

In the southern region of Daisetsuzan, an area most easily accessed by

Furano & Biei: Fairytale Fields of Lavender & Flowers

Furano is a well-known but relatively small city of around 22,000 people, famed for its lavender and flower fields in summer and for skiing in winter, about 37 miles/60 km south (1.5-hour drive) from Asahikawa. Furano occupies a wide valley that connects with the beautiful region of Biei to the north, with low, rolling hills creating a tapestry of farms with crops of varying colors and patterns.

Furano stretches north-south along the main road (Route 237) linking the surrounding regions of the valley. Aside from the city center, which hugs the eastern bank of the Sorachi River, the city is spread out and woven together with farming and agricultural activity. This gives rise to the hand-crafted feel of nature here with the farm's beautifully manicured crops and greenhouses organized with military precision, or perfectly straight rows of tilled earth, ready for cultivation.

Furano is a popular summer destination, well known to Asian tourists, with a pleasant temperate climate and many international visitors, drawn to the famous lavender fields of the iconic and touristy **Tomita Farm** (10-minutes, 12.4 miles/20 km drive north from the city) and its lavender-flavored, soft-serve ice cream (generally 8:30 am to 5 pm, shorter hours outside summer). There are several other beautiful flower farms surrounding the city including

Right Tomita Melon House, where you can feast on Furano's finest melons, or take a gift wrapped melon home with you.

Below Wandering through the vibrant flower fields of Furano. Peak lavender season is usually during July with a wide variety of blooms continuing all summer.

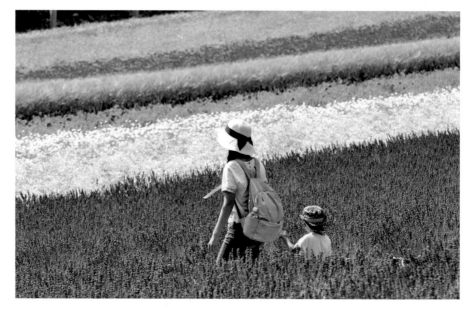

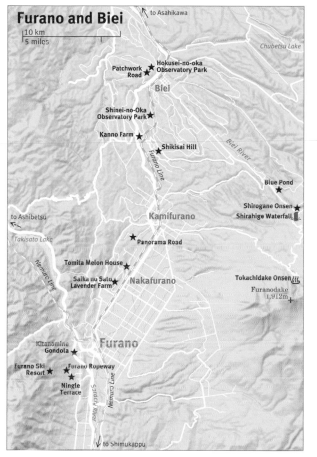

Furano and Biei

Above Fully loaded lavender drying racks after a plentiful new harvest.

Shirahige Waterfall and Blue River

About 30 minutes' (12 miles/20 km) drive from Biei, south-east towards Tokachidake, is the small hot spring resort of Shirogane with a handful of onsen hotels and a campground in summer. In the center of this small village is a footbridge crossing the **Blue River** offering a fantastic view of **Shirahige Waterfall**.

The waterfalls are created by an underground torrent flowing from Tokachidake that cascades 100 ft (30 m) down a rockface into the cobalt blue river below. The water flowing down between gaps in the rocks resembles a white beard, earning it the name Shirahige (white beard) Waterfall.

Saika no Sato Lavender Farm (8 am–5 pm), just five minutes' drive south from Tomita Farm. Furano has long been a summer escape to see beautiful colored landscapes, and to take the time to stop and smell the flowers.

Furano is also a great winter skiing destination with **Furano Ski Resort** (9 am–4 pm early Dec to late-Mar, adult 1-day lift ticket ¥5,500, children under 12 free), accessible straight out of the eastern side of the city. The ski resort consists of two connected peaks dividing the resorts into the Kitanomine zone, accessible from the **Kitanomine Gondola**, and the Furano zone, accessible from **Furano Ropeway** (alongside the New Prince Hotel), just a 10-minute drive (2.5 miles/4 km) south. Furano also acts as the gateway to the

Below Novelty lavender-flavored, soft-serve ice cream—quite delicious actually!

Right Wandering through the forest on the wooden walkways at Ningle Terrace.

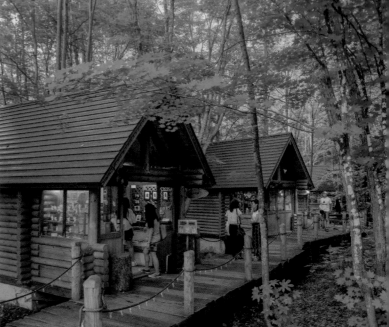

surrounding mountains with some of the most challenging and sought-after backcountry terrain on the island—the next powder frontier.

Also at the base of the New Prince Hotel is **Ningle Terrace** (about 3.7 miles/ 6 km, 10 minutes' drive from the city center). An evening stroll here feels like walking through a fairytale. The collection of beautiful timber cottages, are the charming shops of artisans who create and sell their works here. Nestled in an aromatic grove of pine trees, fairy lights emit a soft glow to light the walkways while the cafés and shops offer quaint sanctuaries of hospitality (12 pm–8:45 pm [10 am–8:45 pm 1st Jul to 31st Aug]).

The Furano Valley is predominantly flat, well-cultivated farmlands as it spreads north to where it greets the rolling hills of **Biei.** A much smaller town than Furano, Biei is surrounded by a picturesque landscape of gently rolling hills and vast fields. This region comes to life and bursts into color from June to October, while winters cover the landscape in snow from December to April, transforming it into a pristine white, yet no less striking, landscape.

A pleasant way to enjoy the charm of Biei is by cycling or driving through the hills and visiting some of the flower fields, exploring the interlinking side and backroads, with every turn a new discovery. The area is broken up into two regions; **Patchwork Road**, describing the area northwest of Biei due to its appearance from the air, and **Panorama Road** referring to the area south of the town, a continuation of the rolling fields with some great vantage points to take in the wider region.

When heading north and exploring this area, be sure to stop at **Hokusei-no-oka Observatory Park** (24 hours, free), no more than 10 minutes' (3 miles/ 5 km) drive from Biei's town center and easily recognizable by the pyramid-style lookout. The area around here has several famous trees and iconic photo locations and can take several hours to explore with endless places to stop.

When exploring south, a great place to stop and take in the region is the **Shinei-no-Oka Observatory Park** (24 hours, free), perched on a small hill on the outskirts of Biei Town (2.5 miles/ 4 km, 10 minutes' drive south). The park is surrounded by fields and sits on a hilltop about 984 ft (300 m) above sea level. With a 360-degree view over the fields of the entire region it is noted as a

Blue Pond

A man-made natural wonder, this artificial pond was created as part of an erosion control system, built to prevent damage to Biei in case of an eruption by nearby Tokachidake. Part of the project required the construction of a small catchment along the Biei River, which over time became **Blue Pond**. The pond's eponymous blue color has not been fully explained but is attributed to the presence of alluvial sediment that reflects shorter wavelength blue light, much like the earth's atmosphere.

Summer is a great time to see the pond by day; in brilliant contrast to the vivid greens of the surrounding forest, the lake is an iridescent and brilliant blue. During the winter months the lake freezes over and is nothing but a perfect sheet of white, with the dead forest rising from its midst. By night the lake is transformed into a wonderland of color and lights; the entire area subject to an evening light show with the lake surface a perfect canvas for it.

The Blue Pond is a 25-minute (12 miles/20 km) drive from Biei and accessible 24 hours a day. There is a large carpark and admission is free.

Above Shikisai-no-Oka looks out over 37 acres (15 hectares) of rolling hillside and large fields of perfectly arranged flower rows. The vibrant colors against a backdrop of the Daisetsuzan Mountain Range create a strikingly beautiful contrast.

great vantage point for some of Hokkaido's most beautiful sunsets.

Another 3 miles/5 km (10 minutes' drive) south is **Shikisai Hill (Shikisai-no-Oka)**, with its panoramic flower fields covering a large area of beautifully manicured hills. Here you can choose to walk the trails, take a tractor ride (¥500), or rent a buggy (¥2,000/15 minutes) to explore the expansive farm grounds. In winter, snowmobiles are available to explore the snow-covered fields with various tour options. Admission to the flower farm is a ¥500 donation.

Another, smaller flower park is **Kanno Farm**; with beautiful flower gardens and lovely views, it is located along the national Route 237 about a seven minute drive (3 miles/5 km) from Shikisai Hill. Admission is free.

Obihiro & the South Coast: Hokkaido's Fertile Breadbasket

Beyond the Daisetsuzan to the east is a wide-reaching farming and agricultural area. Bordered to the north by the Daisetsuzan, and to the south and west by the huge Hidaka Mountains, the lands around Obihiro are threaded by voluminous rivers, as the largest collection of mountains in Hokkaido drains its snow every spring. Obihiro is the hub of this area and a significant city in Hokkaido with around 170,000 residents.

Below As the snow melts from the mountains, it creates a deluge of water, flooding the rivers and powering them as a torrent, surging into spring. Find your adrenaline fix in Hidaka's wild mountains and feel the energy of one of Hokkaido's most powerful seasonal shifts.

The **Hidaka Mountains**—a 93-mile (150-km) long string of mountain peaks rimmed by a thin, fertile strip of land— are Hokkaido's wild side with a sparse population dotted along the coastline in small townships. The wild, forested mountains of Hidaka are vast, with peaks beyond peaks linking up to create a hard-to-access wilderness, as few roads cross these mountains or even penetrate very far in. It's a region of Hokkaido left largely to itself, and the homeland of a large portion of Hokkaido's bears.

Wild and raging, like a rabid bear charging through the forest, are the rivers born from the mountains of Hidaka. Still untamed, this area has an unassuming rawness to its natural power and beauty. This is where Hokkaido's wildest rivers roar and activity centers on adrenaline, with the most challenging rafting and kayaking on the island found here.

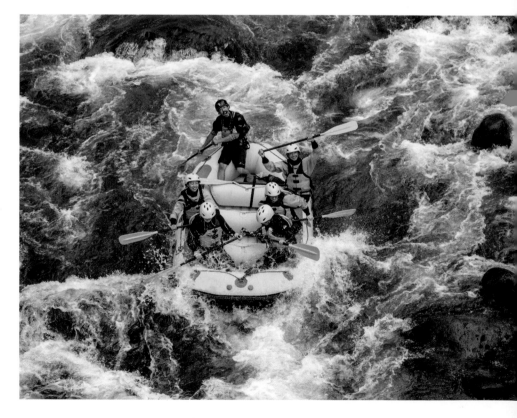

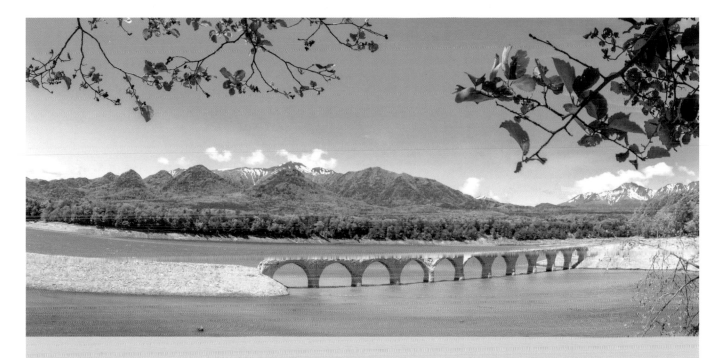

Nukabira: A Hidden Gem

Tucked away in the northwest corner of the of Obihiro region is **Nukabira Hot Spring Resort**, a charming but largely forgotten onsen enclave. Here you will find several onsen hotels including **Nakamuraya**, a beautifully renovated, modern boutique hotel built around a natural hot spring bubbling from the mountainside.

Nestled on the edge of **Lake Nukabira**, the most recognizable landmark is **Taushubetsu River Bridge**—a concrete arch bridge dating back to 1937 when it was built as part of the National Railway Shihoro Line. The construction of Nukabira Dam (and subsequent lake) meant that, in 1955, this part of the line became disused, and so the bridge was given over to the lake. It is commonly referred to as the "phantom bridge" because it becomes completely submerged around June every year, when the water level in the lake rises due to rainfall and melting snow.

The bridge is 427 feet (130 m) long with 11 arches, and is particularly photogenic when it reflects in the still waters of the lake. The observation deck for Taushubetsu River Bridge is less than 10-minutes' drive (4 miles/7 km) along the eastern edge of the lake from Nukabira, while the bridge itself lies on the western side and is a 45-minute drive (15 miles/24 km). If driving this way you will pass **Sannosawa Bridge**—another of the railway's historical remnants—just five minutes (1.9 miles/3 km) out of town on the lake's edge.

The Horse Pulls of Obihiro:
A Hokkaido Tradition

Perhaps the world's slowest, and almost certainly the strangest, this style of horse racing is the only one of its kind on earth.

When early farmers cultivated the land here they relied on powerful draught horses known as Ban'ei. These horses were exceptionally valuable and dear to their owners, often treated as part of the family. The tradition, a test of strength and stamina in which the horses pull heavy sleds, has fostered a horse racing culture in the Tokachi region—especially in the city of Obihiro, the only place that still hosts the races—dating back to 1946. Unlike thoroughbred horse racing, where speed is the deciding factor, Ban'ei racing is a test of strength and stamina.

Obihiro's **Ban'ei Tokachi** is a straight 200 m track with two obstacles along the way—a gradual 3.3 ft (1 m) rise and a steeper, 5 ft (1.6 m) slope. The Ban'ei horses pull 992 lbs (450 kg) iron sleds, bearing additional weights decided according to the horse's age, as they power towards the goal. The track is located in central Obihiro, about a 10-minute car ride (1.2 miles/2 km) from the main train station. Races are held on Saturday, Sunday and Monday with 11 races per day, from 2 pm to after 8 pm. Races are held almost all year round and the track is even heated during winter to prevent freezing. In 2018 there were 568 registered horses with 20 registered jockeys.

In recognition of the event's place in Hokkaido history, Ban'ei horse racing was designated a Hokkaido Heritage in 2004.

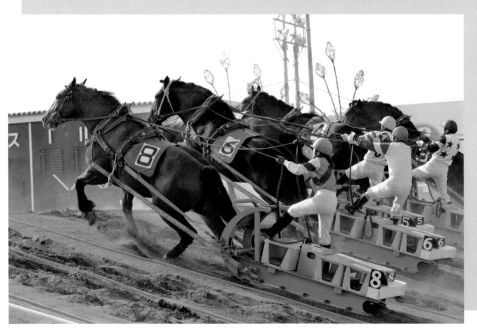

Above and left The huge and powerful Ban'ei draft horses can weigh more than 2,000 lbs (1 ton), about twice that of a thoroughbred. A slow, strange but extraordinarily powerful display when they are at full steam.

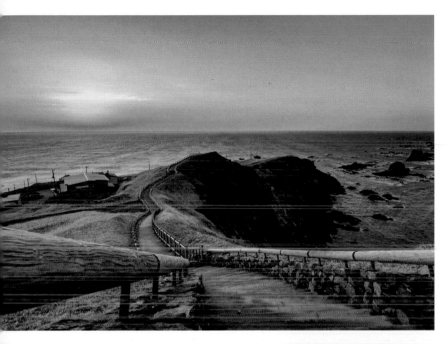

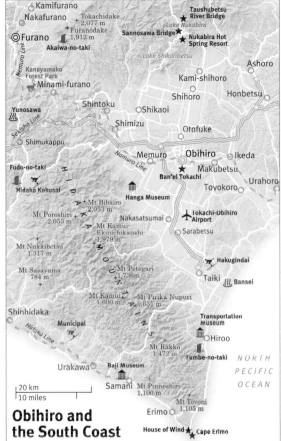

The mountains recede into the Pacific Ocean at **Cape Erimo**, and the western coastline running back to Tomakomai is dotted with small fishing villages along a scenic coastal road. The drive from Obihiro to Tomakomai via Cape Erimo is one of the most beautiful coastal roads on the island, meandering and tunnelling its way through coastal wilderness and mountains whose cliffs plunge into the sea. This drive is around 186 miles/ 300 km and done quickly would take around six hours. However, breaking up the drive with a coastal overnight stop allows enough time to take in this very remote part of Hokkaido.

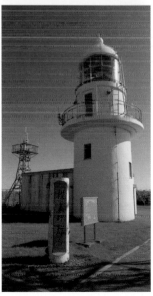

Left The stockily built white lighthouse of Cape Erimo stands defiant in the wind. It is accompanied alongside by the Kaze no Yakata (Wind Museum) an impressive glass-fronted building dug into the cape itself to withstand the wind.

Above left Marking the southern point where the Hidaka Mountains meet the ocean, Cape Erimo's unique geography creates a dense mist, which covers the cape for more than 100 days a year, accompanied by strong winds 300 days a year. It's the perfect home for Japan's largest colony of rare Kuril harbor seals.

Wakkanai & the Okhotsk: Japan's Northernmost Tip

Wakkanai is the final northern outpost on Hokkaido, and the whole of Japan, on the northernmost tip of the island. It is a small city of around 35,000 people and occupies a natural harbor protected from the prevailing westerly winds by the elevated headland of Cape Noshappu. Wakkanai clings to this wind-ravaged northern tip of Hokkaido with an icy grip. Exposed to the wildest weather and cold or frozen oceans, it takes fortitude to carve out an existence here; the city and its inhabitants' enduring enthusiasm for life testament to the legendary Japanese determination.

This remote extremity lies in the mixing waters of the Sea of Japan and the Sea of Okhotsk where they meet in the La Pérouse Strait, below the southern tip of the Russian island of Sakhalin.

Frigid and fertile, these waters bring life to the area with the locals obviously a seafaring folk. Wakkanai also holds significant military and strategic importance, as Japan keeps a watchful

Below Wakkanai sea urchin (*uni*) are renowned for being extremely creamy and delicious. The season is from spring to summer (May–June) and sampling a local sea urchin rice bowl (*uni don*) is the local recommendation.

eye over its northern borders with Russia, and shipping and fishing activity in the Sea of Okhotsk.

The city center is much like any in Hokkaido with nightlife in the streets after dark; the buzz and laughter from *izakaya* creeping through the cracks in doors and windows and rolling down alleyways. A good area to stay is around Wakkanai Station where there are several hotels, a restaurant and entertainment precinct and convenient access to the ferry terminal if your visit includes a trip the islands.

When looking to the west, Wakkanai enjoys one of Japan's most unique views—Rishiri Island, the floating

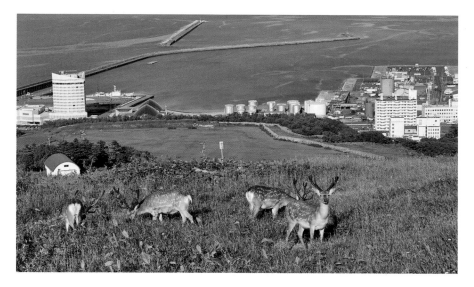

Left Deer grazing in Wakkanai Park overlooking the Wakkanai harbor area. This hilltop park is a 111 acres (45 hectares) recreational reserve for both humans and local wildlife.

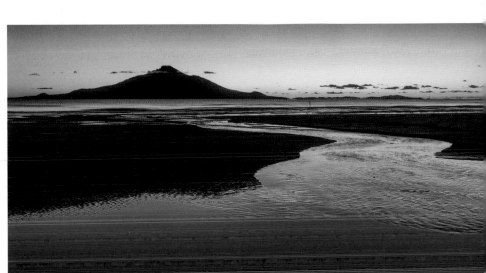

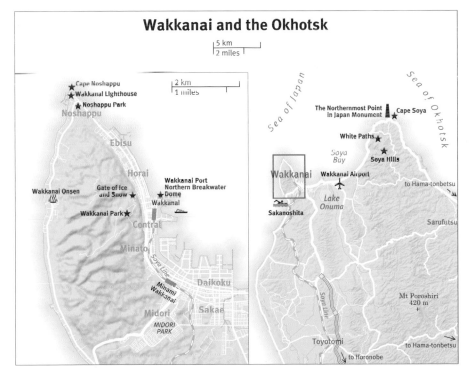

Wakkanai and the Okhotsk

5 km
2 miles

Cape Noshappu
★ Wakkanai Lighthouse
★ Noshappu Park
Noshappu

2 km
1 miles

Ebisu

Horai

Wakkanai Onsen
Gate of Ice and Snow ★
Wakkanai Park ★
Wakkanai Port Northern Breakwater Dome
Wakkanai
Central

Minato

Soya Line

Minami Wakkanai
Daikoku

Midori
MIDORI PARK

Sakae

Sea of Japan

The Northernmost Point in Japan Monument
Cape Soya

White Paths ★

Soya Bay

Soya Hills ★

Wakkanai Airport
Wakkanai

Sakanoshita

Lake Onuma

to Hama-tonbetsu

Sarufutsu

Soya Line

Mt Poroshiri 420 m

Toyotomi

to Hama-tonbetsu

to Horonobe

Sea of Okhotsk

Above left Wakkanai Lighthouse is the tallest lighthouse in Hokkaido and second tallest in Japan. The red and white striped tower stands 140 ft (42.7 m) tall on the very tip of Cape Noshappu.

Above Looking to sunset over Rishiri and Rebun islands from the western coastline near Wakkanai.

mountain in the sea. Not always visible from the shore, as a sea mist often enshrouds the island and its neighbor Rebun Island, clear days provide a mind-bending view of a 5,646 ft (1,721 m) volcano rising directly from the ocean. The symmetrical shape is reminiscent of Mt Fuji and the island mountain has a powerful presence. Looking towards the islands at sunset presents a colorful vista punctuated by the enormous silhouette of Rishiri, gently balanced by the slender line of Rebun along the horizontal plane.

Wakkanai Deer in Noshappu Park

Taking up refuge in the **Noshappu Park** in Wakkanai are dozens of Ezo shika, or Hokkaido deer. At first glance you could be excused for thinking you were in a remote field in Eastern Hokkaido, but these oceanside deer are perfectly happy calling this inner suburban park home.

Unperturbed by human curiosity, the deer go about their daily life grazing in the long grass with the boats of the harbor behind them. Wary but not afraid, a drive past the park is almost guaranteed to provide a glimpse of the deer—but don't be offended if they don't even notice you are there!

Japan has a way of turning the mundane into fun. Pokemon characters brighten up a manhole cover in the streets of Wakkanai.

A 10-minute drive (3 miles/5 km) from Wakkanai station, **Cape Noshappu** marks the tip of the peninsula on the city's east and is one of the best places to take in the sunset. The **Wakkanai Lighthouse** is the second-tallest lighthouse in Japan, at around 141 ft (43 m), and its red-and-white-striped appearance also sees it ranked as one of the best 50 lighthouses in the country. Japan's northernmost onsen, **Wakkanai Onsen**—which was discovered when prospecting for oil—is a five-minute drive (2.5 miles/4 km) from the cape on the eastern side.

About 15-minutes' drive from the city's hotel district will take you up to **Wakkanai Park** where a collection of monuments overlooks the Sea of Okhotsk and north to Russia. One of the most iconic of these is the **Gate of Ice and Snow (Hyosetsu no Mon)**, built in 1963 as a memorial to those who lost their lives in disputes with Russia over the island of Sakhalin, which was once part of Japan.

It consists of gates of remembrance, a memorial stone and a bronze statue symbolizing the people who fought to survive in the snow and ice. Beyond the gates, you can see Sakhalin island itself.

Lake Onuma—30 minutes' (7.5 miles/ 12 km) drive east from the city center— sees the arrival of migratory whooper swans from late-March to late-May, and October to November. If visiting in winter, Lake Onuma hosts the **Japan Cup National Dog-Sled Competition**— one of the biggest dog sledding competitions in Japan—during the last weekend of February in a park area close to Wakkanai's airport. Admission is free.

In peak summer, the first week of August sees the **Wakkanai Minato Antarctic Festival** which, like most cities' festivals, involves dancing, food, drink and fireworks. It is held at the **Wakkanai Port North Breakwater Dome**, a repurposed submarine repair station from WWII and a short walk from Wakkanai Station.

The Incredible Road from Wakkanai to Abashiri

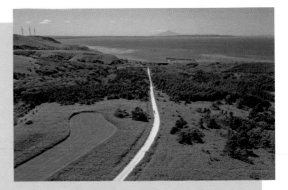

Enveloped by floating sea ice in winter, the coastline is forebodingly beautiful and is one of the least-visited areas of Hokkaido. Driving along the coast with its long stretches of beachside roads, it certainly has the feel of remote isolation as you pass through infrequent towns. It's an adventurous part of Hokkaido to explore by camper van or with a tent. There are many options where you can stop for a night, pitch camp, and soak up the natural surrounds. Time moves slowly up here and being in no hurry allows you to drive all the little roads that link up along the coast, or even venture to the dead end of a beach road to find an undiscovered gem. If arctic waters and potential encounters with seals or orcas are no deterrent, there are also some uncharted surfing possibilities.

The cold sea waters are powerfully fertile and bring abundant life, and the Sea of Okhotsk is known as one of the most productive in the world. With plentiful sealife comes birds in huge numbers. It's easy to understand why this stretch of coastline is known as a bird-watcher's paradise and why this icy ocean is the domain of the giant coastal predator, the *owashi* (Steller's sea eagle).

Be sure to start this road trip with the scenic route by driving over Soya Hills through the White Paths—a road made from crushed scallop shells. From here there are stunning views over vast, rolling hilltop meadows to Rishiri Island in the distance.

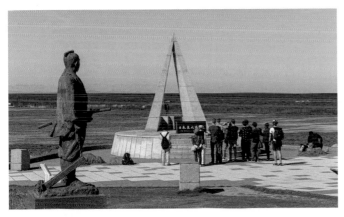

Cape Soya marks the northern most point of Japan with a celestial pyramid style monument, sensibly named: The Northernmost Point in Japan Monument. Looking out from here on a clear day you can see the Russian island of Sakhalin.

Cape Soya is a 40-minute (30 miles/ 37 km) drive east along the coast and at the lookout you will find **The Northernmost Point in Japan Monument** (although the true northernmost point under Japanese control is a small, deserted rock island called Bentenjima 0.6 miles/1 km to the northwest). This point is renowned for its sunsets and on a clear day has views to Sakhalin Island to the north.

The **Soya Hills** are located just inland from Cape Soya. This unique periglacial landscape was formed during the Ice Age and is designated as a Hokkaido Heritage. Winding through the hills are narrow roads paved with crushed scallop shells, known as the **White Paths** for their distinctive color (open May to October). You may encounter free-range cattle sharing the scene with you as you wander the hills. More than 50 wind turbines are installed amongst the rolling landscape and you can expect to see more in the surrounding area nestled along the coastline—an indication of the prevailing weather conditions.

Rishiri & Rebun Islands: Floating Mountains in the Sea

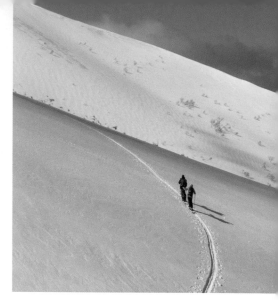

Rising like a wild sea creature from the ocean floor and standing ominously in a cold and foreboding sea is Rishiri Island. Lashed by violent winds and tormented by some of the most ferocious weather on earth, Rishiri's peak rises to 5,646 ft (1,721 m) at the island's center—a gnarled mass of deadly spines and icy ridges. The island is rimmed by a small swathe of habitable land, tended by some of the world's most resilient people.

Rebun Island lies to Rishiri's north and in contrast, is a low-altitude, long, narrow island with a milder temperament. Rebun is famous for its wealth of alpine flowers that are found at sea level due to the harsh climate. The islands are part of the Rishiri-Rebun-Sarobetsu National Park and offer visitors beautiful hiking trails, spectacular scenery, and small, authentic fishing villages. In

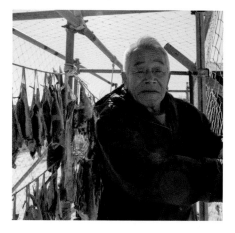

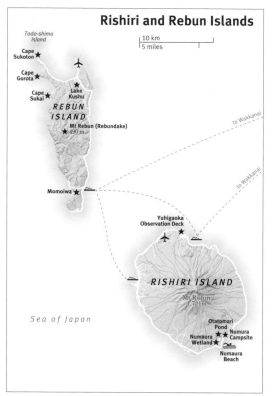

Rishiri and Rebun Islands

Todo-shima Island
10 km
5 miles
Cape Sukoton
Cape Gorota
Cape Sukai
Lake Kushu
REBUN ISLAND
Mt Rebun (Rebundake) 490 m
to Wakkanai
Momoiwa
to Wakkanai
Yuhigaoka Observation Deck
RISHIRI ISLAND
Mt Rishiri 1,721 m
Sea of Japan
Otatomari Pond
Numaura Wetland
Numura Campsite
Numaura Beach

Above Ski touring on Rishiri Island, a snow covered volcano rising from the sea, provides unfathomably panoramic views unlike you will see anywhere else on earth.

Far left The weathered faces of Rishiri's hardened fishermen tell a lifetime of tales.

Right Undoubtedly some of Japan's finest *uni* comes from the cold, nutrient-rich, kelp-infused waters of these islands.

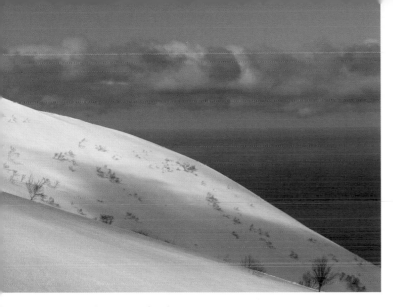

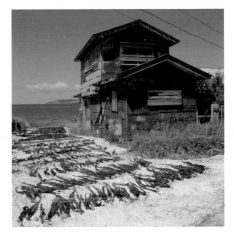

Right Neatly arranged kelp lies drying in the sun alongside a weather-beaten house on Rishiri.

Below Celebrating a fresh catch! All around the island you will see locals on the water's edge using long poles, fitted with special hooks, trying to select the best pieces of kelp to drag onto the rocky shore.

winter, for expert backcountry skiers and snowboarders, Rishiri has some of the most challenging and spectacular terrain in Hokkaido with unfathomably panoramic ocean views.

While Rishiri has its own airport, a ferry from Wakkanai is the most convenient way to reach the islands using the Heart Land Ferry Terminal, a five-minute drive from JR Wakkanai Station. The ferry ride to Oshidomari Port on Rishiri takes around 1.5 hours

(from ¥2,550 for passengers, ¥12,830 for vehicles, 2–3 ferries per day). Alternatively you can cross from Wakkanai to Rebun (about 2 hours) and then to Rishiri afterwards.

Rishiri lies about 32 miles (52 km) west of Wakkanai. A 39 mile (63 km) circumnavigation of the island by car takes around two to three hours. Setting out from Oshidomari Port in the town

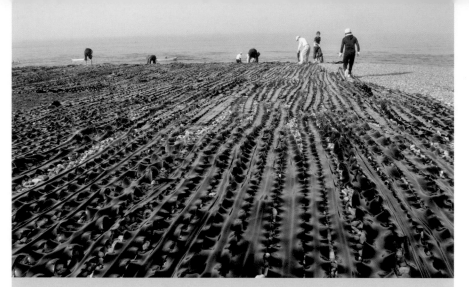

Kombu Seaweed Farmers
of Rishiri Island

As with much of Japan, Rishiri's residents are maritime people, living with and from the ocean. Early settlers were blessed with rich oceans and quickly developed a flourishing industry, underpinned by seemingly endless stocks of herring. In more recent times, with stocks depleting, Rishiri's residents have adapted to cultivating and harvesting "kombu"—kelp.

A source of food in Japan for over 1,000 years, the list of dishes that contain kombu is endless. Rishiri kombu is known to be slightly sweet, saltier and harder than its mainland counterpart. Its broth is rich, savory and clear, and these distinct characteristics make Rishiri kombu a popular choice for tea ceremonies in Kyoto.

In many of Rishiri's villages you will see kombu harvested using a traditional sun-drying method. Since this requires full sunlight, kombu cannot be harvested on cloudy days, even if the sea is calm. Traditional harvesters may wait for days or even weeks for suitable weather conditions to take their boat out for the next harvest. These fishermen brave the coldest oceans, dragging in their kelp ropes, while old ladies appear at the water's edge, skilfully dragging the harvest from the rock-lined edges of the shore with their specialized, home-made hook poles.

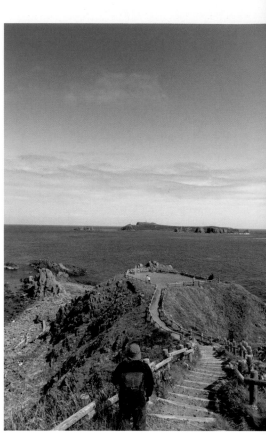

Walking down to Cape Sukoton on Rebun Island's northern tip. Lying in the waters beyond is Todo island, marking the end of Hokkaido's northern island group.

of Rishirifuji, you can drive in either direction—heading clockwise toward Wakkanai are plenty of great photo opportunities, including harbors, fishermen sheds and drying racks as well as many small shrines that are testament to the spirituality of this special island.

A nice stop is **Otatomari Pond**—the

largest body of water on Rishiri Island—which sits in the foreground of beautiful views to Mt Rishiri. There are wooden paths that create a loop around the lake through **Numaura Wetland**—about a 20-minute walk. Five minutes' walk from the parking lot at the pond is **Numaura Beach,** one of Rishiri's only sandy beaches. About 0.3 miles (500 m) back up the hill from the pond is the **Numaura campsite**—a free campsite with space for around 20 cars.

Once back on the northern side of the island, **Yuhigaoka Observation Deck** on the western edge of Rishirifuji Town is a short walk up some stairs and along a small trail to a 148-ft (45-m) high viewing platform offering great sunset views across to Rebun Island.

Rebun is about 6 miles (10 km) north of Rishiri and is entirely different in character. Longer and flatter than Rishiri, Rebun measures 18 miles (29 km) north to south and just 5 miles (8 km) east to west with its highest point Mt Rebun rising to 1,607 ft (490 m). Trekking is the best way to enjoy Rebun with many hiking trails covering the island. The western coastline, bearing the brunt of the prevailing westerly winds, is a jagged collection of cliff faces and striking scenery, while the east is tamer, with similarly beautiful views. There are six main hikes, the start and finish points of which are all linked by a bus service covering the island.

Located along a finger of land protruding from the northwest of the

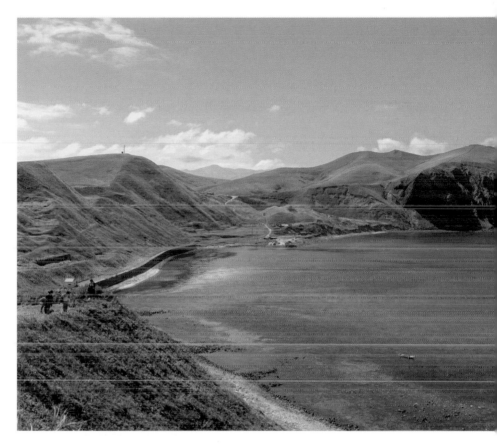

Rebun Island is interwoven with many small roads and hiking trails that have constant vistas of the green hills and cliffs falling into the blue seas around. There are several designated hiking courses to explore the multitude of capes and coves across the island.

island, are **Cape Sukoton, Cape Sukai,** and **Cape Gorota,** which offer incredible landscapes and can all be visited within one day. **Lake Kushu** has a 2.5 miles (4 km) trail looping it, and is a great site for bird watching. In the south,

Momoiwa is an impressive rock standing 820 ft (250 m) high and said to be shaped like a peach. Nestled in a wilderness of alpine plants it is designated as a natural monument of Hokkaido and can be seen via a two-hour (3.3 miles/5.3 km) hiking course.

There are also treks to the highest peak on the island, **Mt Rebun (Rebundake),** and a longer course (8 hours, 10.6 miles/17 km) making a north-south traverse across the island.

The Far East: Into the Wilds

A wilderness unknown and a beauty untouched, the far east of Hokkaido is a land of abundant and unique wildlife and endless nature. Extending from the Daisetsuzan Mountain Range in the west to the Shiretoko Peninsula in the east, this is a vast area of predominantly lush farming land. It stretches from Obihiro—encompassing marshlands and the city of Kushiro—to Hokkaido's most easterly point at the tip of the Nemuro Peninsula, looking towards the remote but not forgotten islands of pre-World War II Japan.

In the center of this region is a collection of large and beautiful lakes with steaming volcanoes and hot, lakeside onsens. The volcanic area surrounding Teshikaga and the active and ever-billowing volcano of Mt Io includes three of Hokkaido's most beautiful lakes—Mashu, Kussharo and Akan.

From this lake area reaching northeast runs a battery of mountain peaks, home to the limitless forests of UNESCO World Heritage Site, the Shiretoko Peninsula. This untouched wilderness is home to Hokkaido's largest population of bears, deer and the magnificent *owashi* eagle (Stellar's sea eagle), as well as being one of the last remaining habitats for one of the rarest owls on earth—the Blakiston's fish owl.

Shiretoko is a true wilderness, a wild kingdom where primeval nature continues to reign supreme. It is where the wild things are, and one of the least explored corners of Japan.

Encased by a girder of ice in winter, this far eastern corner of Hokkaido is a cold and foreboding place, somewhat offset by stunning landscapes. Stark and inhospitable winters grip this region and arctic winds bring sea ice from the northern coasts of Russia. Contrary to appearances, the region comes to life with bird migrations at this time of the year, when the brilliant *tancho zuru* (red-crowned crane) and whooper swans call this region home. The great *owashi* eagles soar along the coastline pulling fish from the ocean and roosting proudly in towering nests.

In summer the far east's wide farmlands and dense forests burst to life as the region is taken over by vibrant green.

Ainu ancestry and culture is woven deeply into Hokkaido's history with Lake Akan recognized as a traditional Ainu homeland.

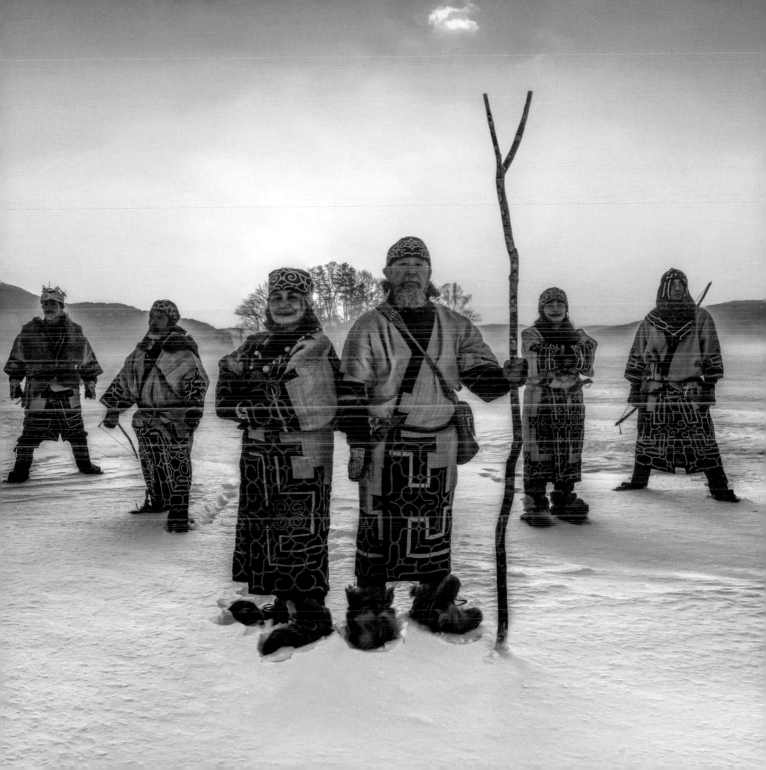

Kushiro to Nemuro
Hokkaido's Far Eastern Tip

Kushiro is a notable coastal city in Eastern Hokkaido and, with an airport, it is also the primary entry point for anyone choosing to arrive in the region without driving from the western side of the island. After Obihiro, Kushiro is the next major center and last town of notable size as you head further east towards Shiretoko or the Nemuro Peninsula. Kushiro marks the gateway to the east's natural wonders and is a hub for day trips to the lakes or the special sanctuaries of the *tancho zuru* (red-crested crane) and other migratory birds that call this region home.

From the northern outskirts of the city, the Kushiro Marsh extends outwards creating a huge natural habitat for birdlife. The **Kushiro Marshland (Kushiro-shitsugen)** was designated as a national park in 1987 in order to preserve Japan's largest wetland and marsh habitat supporting the only known population of endangered Japanese cranes. About a 30-minute drive (10 miles/16 km) north of the city is the **Kushiro Marsh Observatory** (8:30 am–6 pm May to Oct [9 am–5 pm Nov to Apr]), the starting point for walks through the marsh, with an information center and panoramic views over the wetlands.

About another 30 minutes' (18.6 miles/ 30 km) drive west from here is the **Akan International Crane Center** (8:30 am– 5 pm [8:30 am–4 pm Nov to Jan], ¥470 adults, ¥240 for elementary students); established in 1996 as a research center and feeding facility to protect the species. Through the winter months, from November to March, the neighboring **Tancho Crane Observation Center** (8:30 am–4 pm) provides daily feeding for around 300 cranes, attracting bird

Photographers line the fences of the Tsurui Ito Tancho Crane Sanctuary daily in winter, hoping for that illusive shot of the perfect dance of the *tancho zuru.*

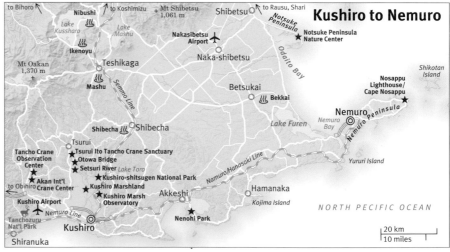

Left Looking out over the wetlands of the Kushiro-shitsugen National Park.

Tancho Zuru: The Red-Crested Crane

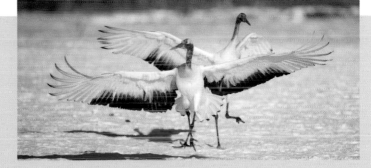

One of nature's most wondrous creatures, the *tancho zuru* (Japanese red crested crane) is an icon of Japan that was almost lost to the world forever. Thought to be extinct due to overhunting and habitat destruction, in 1926 a group of about 20 birds was discovered in the marshes around Kushiro. With conservation efforts they have since made a dramatic recovery and now number more than 1,000 birds. With careful management, habitat protection and feeding programs by locals, the *tancho zuru* have rebounded and still call the marshlands of Kushiro and surrounds their home.

The cranes are most spectacular to watch as they dance, often in pairs, with seemingly choreographed dips and jumps. They are best seen in the winter as they gather at various feeding sites. Standing at around 59 in (150 cm) tall, these beautiful birds have a

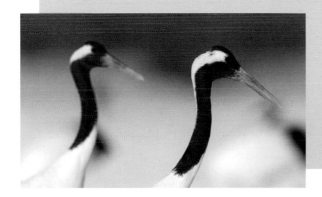

famous and flamboyant dance routine that serves as a mating ritual. This wonderful display of plumage, hopping, jumping and squawking is extraordinary and a wonder to behold.

The birds can be viewed at varying times of the day from several different points around Kushiro. Starting their mornings waking up at the Setsuri River near Otowabashi (Otowa Bridge), the birds quickly take flight and move to common feeding areas, where they stop to parade, dance and socialize while feeding and delighting the avid wildlife photographers who pursue them each winter.

The Notsuke Peninsula: A Natural Wonder

The Notsuke Peninsula is Japan's largest sand spit—a 17.4 mile (28 km long), hook-shaped strip jutting out into Nemuro Strait on the eastern edge of Hokkaido. This wisp of land is surrounded by a shallow wetland (Odaito Bay) on one side and raw ocean on the other. The site is a haven for birdlife, drawing enthusiasts from all over the world, and you can also expect to see foxes, deer, and eagles in great numbers as they search for food.

This narrow strip of land provides a unique ecosystem and an equally interesting landscape of sunken forests, frozen wetlands, sea ice and, in summer, vast swathes of native flowers. Away from the regular tourist trails, the peninsula has stunning vistas of the Shiretoko mountains and offers close encounters with wildlife. The **Notsuke Peninsula Nature Cente**r (9 am–5 pm [9 am–4 pm Nov to Apr], free) is about 9.3 miles (15 km) along the peninsula and offers an indoor viewing station with information provided by local nature guides about the wildlife of this remote corner of Hokkaido. From here there are walks leading out into the bay and further along the peninsula, beyond where vehicles are permitted.

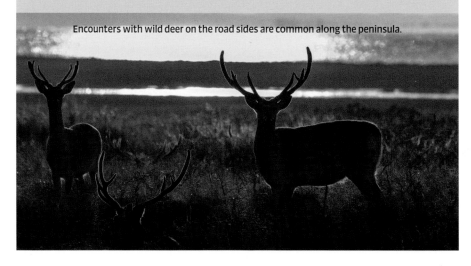

Encounters with wild deer on the road sides are common along the peninsula.

Akkeshi oysters are a regional speciality, famed for being smaller but with very sweet, plump and juicy meat.

watchers and photographers for a close encounter with these rare birds.

Akkeshi, neighboring Kushiro to the east (1 hour's drive, 31 miles/50 km), is a famed oyster producer. "Akkeshi" is the Ainu word for "oyster place," and Lake Akkeshi is their natural source. There are two especially great ways to experience oysters from Akkeshi: in the last half of May, the nine-day-long

Above Exploring the Kushiro-shitsugen National Park by canoe is the best way to encounter some of the park's native birds and wildlife in their natural environments.

Above Cape Nosappu, Hokkaido's most easterly point, which looks out to the southern Kuril Islands, or "Northern Territories", claimed by both Russia and Japan.

Akkeshi Sakura and Oyster Festival is held in **Nenohi Park** where you can enjoy charcoal grilled seafood whilst sitting under cherry blossom trees, or at the beginning of October at the 10-day **Akkeshi Oyster Festival**, which offers a smorgasbord of Akkeshi flavor, from grilled oysters to oyster ramen and oyster rice.

Driving on toward Nemuro, in just over an hour (43.5 miles/70 km) you will arrive at **Lake Furen**, a large brackish lake (a mix of salt and fresh water) and a nature reserve for over 300 species of birds. The perimeter of the lake is about 59.6 miles (96 km), with a maximum depth of 36 ft (11 m). The lake is famous as an area for seeing white-tailed and Steller's sea eagles and is one of Japan's largest breeding grounds for white swans.

Arriving in Nemuro, despite the remoteness of the region, the town feels surprisingly large, reinforced by the fact it is home to almost 30,000 residents. It occupies the northern nape of a headland that extends eastward with **Cape Nosappu** at its tip. It is the easternmost point of Hokkaido, and the first place in Japan to see the sunrise. The **Cape Nosappu Lighthouse** occupies the headland and is the oldest in Hokkaido, built in 1872.

Cape Nosappu extends eastward from Hokkaido as if reaching for the lost islands of Japan.

Before the end of World War II, when much of this northern territory of Japan was reassigned by the USA and Russia, Japan extended beyond Hokkaido to the Arctic, including parts of the Aleutian Islands that stretch westward from Alaska. Within Japan there is still a clear belief that these island territories belong to the Japanese archipelago. The Northern Territories dispute is a disagreement between Japan and Russia over sovereignty of the southern Kuril Islands, including two of the larger islands—Iturup and Kunashir—and the Shikotan and Habomai islets, all visible from the lookout at the end of the Nemuro Peninsula.

Right Cape Nosappu lighthouse first illuminated this cape in 1930 and is an important safety beacon along this rocky and treacherous coastline.

Lake Akan: The Ainu Homeland

About 90 minutes' drive from Kushiro, or an hour from the Akan Mashu National Park's other lakes, nestled in a crater between two large volcanoes is Lake Akan, with its spectacular scenery and deep connection to Ainu history and culture. Mt Oakan, "male mountain", (4,495 ft/1,370 m), on the northeastern shore of the lake, sits opposite his female counterpart, Mt Meakan (4,918 ft/1,499 m). Eruptions from this pair of volcanoes have formed the landscape around Lake Akan, and Mt Meakan remains active with sulfur fumaroles venting from its heated core.

Lake Akan contains four small islands and is world-renowned as a habitat for the marimo of Lake Akan—a rare species of spherical seaweed that is designated as a Special Natural Monument of Japan. An onsen district, **Akankohan**, is tucked in along the southern bank with several hotels and a collection of shops. Sightseeing boats leave from here for cruises of the lake and in winter there are snowmobile and ice fishing tours once the lake fully freezes over between December and March.

Above Ainu carvings regularly represent the animals of Hokkaido that hold great cultural significance. Here an owl adorns a tall timber pole in the Ainu Kotan.

Below left Looking down into the crater of Mt Meakan, an active volcano with two colored ponds in its crown.

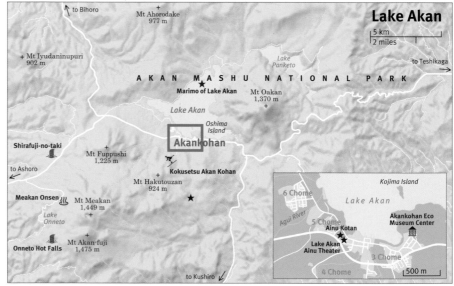

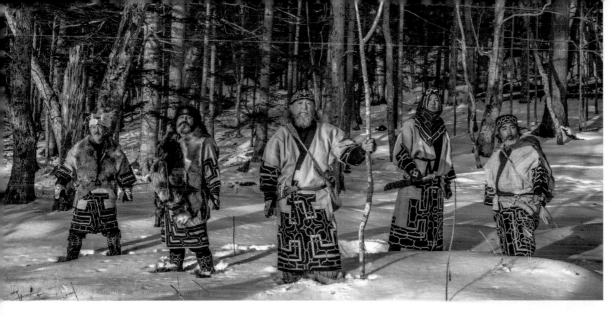

Ainu Kotan, a small Ainu village in Akankohan, is a street lined by souvenir shops specializing in Ainu handicrafts. While it may not seem an entirely organic attraction, at the end of the street there is a small museum, the **Ainu Folklore Museum** (9 am–9 pm, free) displaying traditional Ainu crafts, clothes and daily life utensils, and at the top of the street, the **Akan Ainu Theater Ikor**, which hosts traditional Ainu rituals and performances.

At the town's eastern edge, **Akan-kohan Eco Museum Center** (9 am– 5 pm, closed Tue, free) has information on **Akan Mashu National Park** and its wildlife. From here walking trails lead through the forest and along the lake to bubbling mud pools known as *bokke* and a roundtrip will take around 40 minutes. This area also offers some great hikes to either of the volcanoes.

Mt Oakan has just one trail that

Left Fat bike tours are a great way to explore the forest trails and lesser know lakeside spots around Lake Akan.

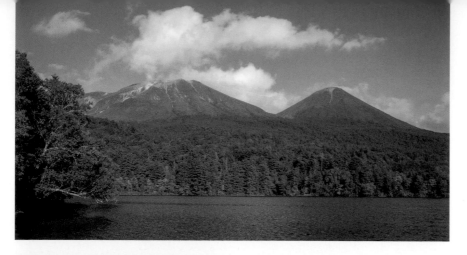

Lake Akan to Oakan. It then descends back through the forest to the stunning **Lake Onneto** with the option for a small detour to the **Onneto Hot Falls**—109° F (43° C) onsen water cascading down some 98 ft (30 m) of moss-covered rock.

These mountain trails are passable between May/June and October. Outside of these months expect to encounter snow on the trails.

THE AINU

Before the deliberate settlement of Hokkaido by the Japanese government in the late 1800s, the island was the primary homeland of the Ainu people. Sparsely populating the island and spreading further north to Sakhalin and the Kuril Islands, the Ainu are regarded as a strong and resilient

Above The view from Lake Akan to Mt Meakan and neighboring Mt Akan Fuji to its right.

Left The bubbling volcanic lakeside mud pools, or *bokke* in the native Ainu language.

Below The rivers and streams around Lake Akan are renowned for great fishing, drawing fly fishing enthusiasts from all over Japan. Fishing is highly controlled so be sure to obtain a permit before casting a line.

starts from the eastern end of Lake Akan, about 2.5 miles (4 km) from Akankohan. The hike to the summit is around 7.8 miles/12.5 km (allow 5–7 hours). Alpine flowers are plentiful and views over the lake and back towards Mt Meakan and neighboring **Mt Akan Fuji** (4,843 ft/1,476 m) are truly stunning.

Mt Meakan's most commonly used course is on the west side of the mountain leaving from **Meakan Onsen**— about a 20-minute drive (11 miles/ 18 km) from Akankohan. The course is a 6.2 mile (10 km) loop and will take about 6–7 hrs. This trail takes in the steaming, alien scenery of Meakan's volcanic crater with views back over

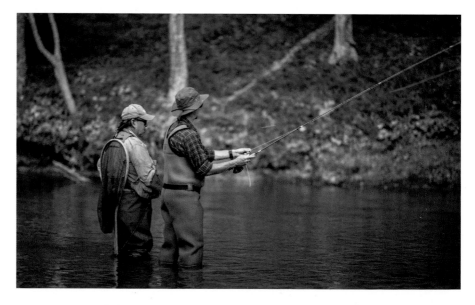

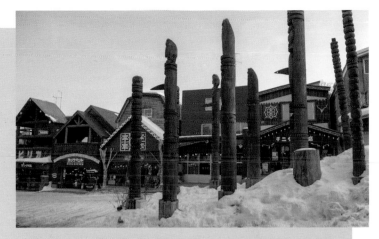

Experiencing Ainu Culture

The Ainu's intimate connection to Hokkaido is perhaps best experienced through their dance—an expression of their relationship with nature, wildlife and the seasons of Hokkaido. The Ainu Ancient Ceremonial Dance is registered

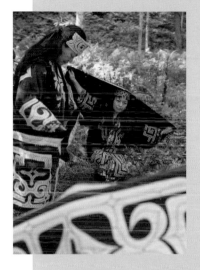

as a UNESCO World Intangible Cultural Heritage and is a beautiful glimpse into the life and culture of the Ainu.

At the **Lake Akan Ainu Theater** (located at the top of Lake Akan Ainu Kotan) you are able to experience recreations of these traditional dance performances. Akan Yukar "Lost Kamuy" is a production that combines digital art, 3D imagery and sound design with ancient ceremonial dances intended to emulate the movements of nature and help the Ainu commune with the *kamui*, or divine beings.

The performance takes around 40 minutes and is held year round (9:15 pm Mar to Apr, 3 pm and 9:15 pm May to Oct, adults ¥2,200, children ¥600).

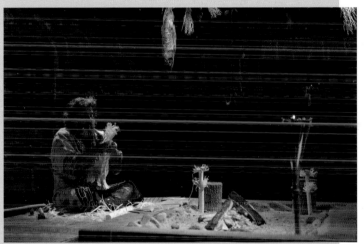

Left above Ainu women performing a traditional dance inspired by movements of the local birds and animals.

Left A carved wooden owl marking the entrance to the Ainu Theater—Ikoro.

Top Kamuyni (Trees of The Spirits). This collection of tall carved poles is a special creation completed in 2009 as a symbol to pass on the heritage of the Ainu Kotan. They were created by internationally acclaimed artist Nuburi Toko and a team of villagers from Ainu Kotan.

Above An Ainu man demonstrates the traditional skills and cultural pastimes of the Ainu.

The Secret of the Marimo Balls

Lake Akan is home to marimo, a rare species of algae that forms beautiful green balls that are soft and velvety to the touch. This unusual plant is a protected species and designated a national Special Natural Monument. They live in shallow waters around the lake's edge, rolling around as gentle waves lap at the lakeshore. They grow slowly, and if left to mature fully, can grow to the size of a soccer ball—twice the size of marimo anywhere else in the world.

You might see a little green man with a bulge in his pants—Marimokkori—on sale in various forms at souvenir shops. Marimokkori is inspired—and perhaps aroused—by Lake Akan's unique green algal balls.

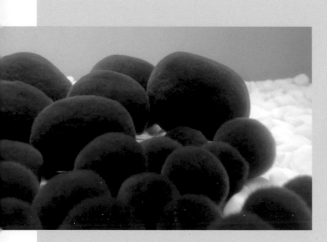

people with an ancient culture connected to the animals and nature of the island. Hokkaido's town and location names often stem from their original Ainu names and differ from the traditional Japanese names.

As Hokkaido's indigenous people, the Ainu have a long and deep history connected to this island. Said to have evolved from the first inhabitants some 10,000 years ago—the Jomon, Satsumon and the Okhotsk people—the Ainu have been living in harmony with the seasons of Hokkaido for centuries, with their current culture dating back to about 1400. In such a wild and inhospitable environment, it is testament to the rugged and hardy nature of the Ainu that first settled the island and overcame great challenges to carve out an existence in Hokkaido.

Above The green marimo balls of Lake Akan.

Right Three Ainu men dressed in traditional woven coats and clothing including a bear skin. The Ainu's history is one of resourcefulness and connection to the wild nature and environment of Hokkaido.

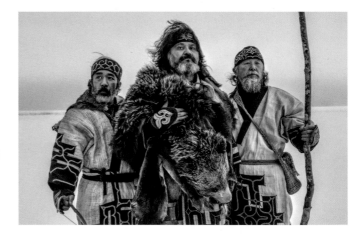

The Japanese maintained trade relations with the Ainu during the Edo period (1601–1868) but a series of unsuccessful Ainu revolts and the spread of diseases such as smallpox contributed to the annexation of Hokkaido in 1869. Almost 30 years later, the Meiji government enacted the Hokkaido Former Aborigines Protection Act, which, however, still placed restrictions on some traditional Ainu practices, such as hunting which forced a cultural adaptation towards farming. This act was repealed in 1997 but the century

that passed had seen the Ainu endure a great change from their ancestral past.

The modern center of Ainu culture is based in Akan. Modernized and largely skewed toward tourism and souvenirs, the village can feel a little hollow and treads a fine line between positive recognition and distraction from the underlying issues. However it cannot be denied that Ainu Kotan provides an insight into the traditional people's innate understanding of life, nature and their deep connection to the soil and the snow.

There are several other significant Ainu settlements and homelands across Hokkaido, including Nibutani—a district in the town of Biratori in Hidaka. The population is around 400 people with over 80% of residents having Ainu heritage. Here you will find two Ainu museums; **Kayano Shigeru Nibutani Ainu Museum** and the **Nibutani Ainu Culture Museum** (9 am–4:30 pm, closed Mon, ¥400 for adults, ¥150 for students—per museum, or ¥700 /¥200 for both). There is also Sapporo's **Hokkaido Ainu Center** (9 am–5 pm, closed Sun, free), run by the Ainu Association of Hokkaido, with exhibitions of Ainu tools and handicrafts and an extensive library of books on their history and culture. See also Upopoy Ainu Village (page 55).

Below Ice fishing tents dot the surface of many of the frozen lakes in Eastern Hokkaido—A colorful array of life in an otherwise desolate white landscape.

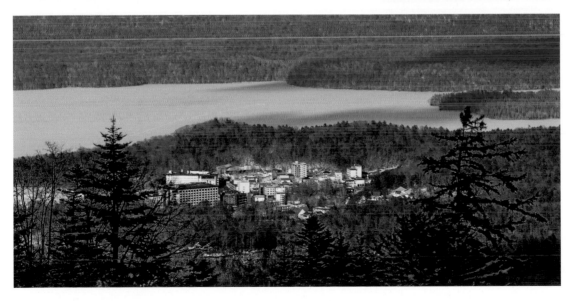

Left Looking over the township of Lake Akan to the frozen lake beyond.

The Lakes District: Lake Kussharo and Lake Mashu

About 90 minutes' (43.5 miles/70 km) drive south from Abashiri, the lakes of Mashu and Kussharo sit on opposing sides of the active and steaming volcano of Mt Io. This is an area with spectacular lake views and hidden natural onsens.

Lake Kussharo is Hokkaido's largest caldera lake by surface area and also the largest lake in Japan to freeze over completely in winter. A larger lake than neighboring Mashu, Kussharo has a volcanic crater wrapping around most of its northern side. There is a great lookout at **Bihoro Pass**, just a short hike up from the rest stop where the road from Abashiri crests the northwest corner of the crater.

Nakajima Island rises near the

Above Pancake sea ice floating on the clear waters of the Sea of Okhotsk. This seasonal wonder occurs annually during the deep-winter months.

Below Sunrise from the summit of Mt Meakan overlooking Lake Akan with Mt Oakan rising from the lake's eastern shore.

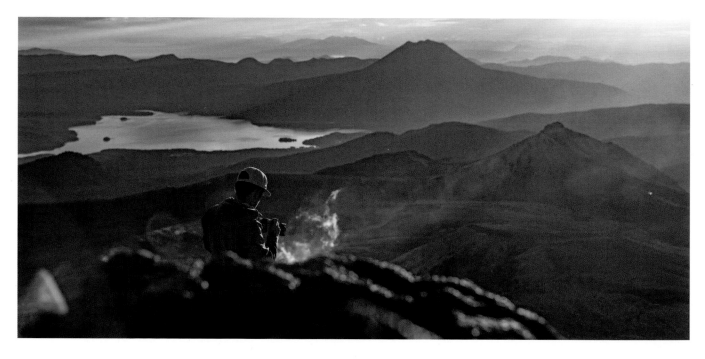

center of the lake, with the Wakoto Peninsula reaching out towards it from the lake's southern shore. Several natural hot springs bubble to the surface along the lake's edge, mixing with the lake water and preventing these pockets from freezing.

Camping, boating, canoeing, sailing, windsurfing and fishing are fun summer activities enjoyed on the lake, and there are several campgrounds around its southern and eastern sides which make for a perfect base to explore the area and relax by the water.

To the east of Lake Kussharo is **Mt Io**, an active volcano known to have erupted liquid sulfur, to which its

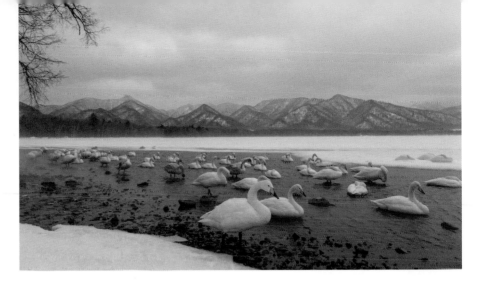

Above Every winter a bevy of around 300 whooper swans returns to Lake Kussharo. You can find them along the shoreline or paddling in the edges of the lake where the ice is melted by hot spring water.

Below Lake Kussharo is dotted with magical onsens overlooking the lake. These natural hot springs, situated right on the lake's edge, provide a continuous flow of warm water and are a place of pure tranquility.

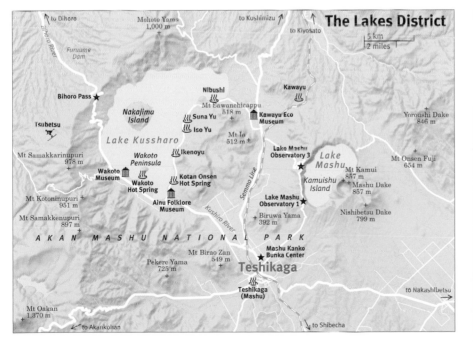

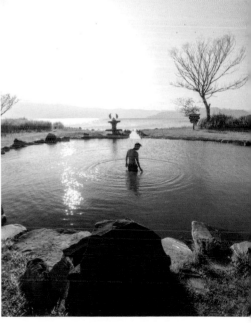

The Amazing White Whooper Swans

Each winter more than 300 migratory whooper swans leave their Siberian homelands and arrive at Lake Kussharo. These beautiful, perfectly white birds are attracted to areas of the lake's edge warmed by onsen water and free from ice. These thermal hotspots provide sanctuary from the intense cold as they splash in the water, dipping their heads, preening and grooming themselves.

These birds can be seen as solitary icons, cruising the waters of the lake between the ice, or in flocks congregating on the shoreline. They are reliable visitors to the sandy beach alongside Suna Yu onsen, on the lake's eastern shore, providing the best opportunity to see these exquisite creatures. They are a symbol of elegance and beauty and breathe life into frozen Lake Kussharo each winter.

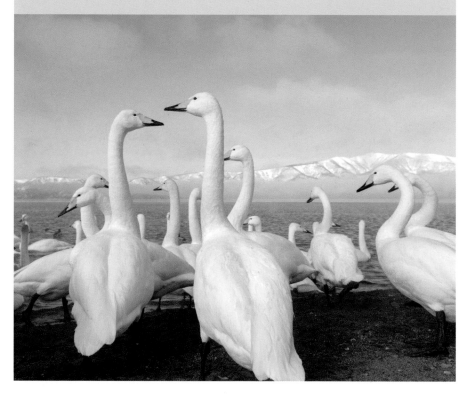

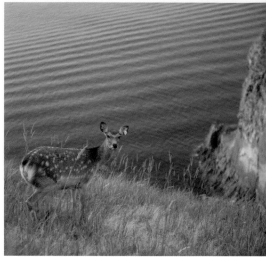

Above Deer are a common sight in Hokkaido with a large population spread across the island. The Ezo sika deer, a subspecies of the sika deer, are indigenous to Hokkaido.

continuously billowing, yellow-rimmed sulfur fumaroles will attest. From the carpark it is a five-minute walk across a small, flat wasteland where you can view the vents up close and take an intimate look at the volcanic activity that has formed much of the area.

To the east and slightly south of here lies **Lake Mashu**, a body of crystal-clear water captured in the bottom of an extinct volcanic caldera. Famous for containing the clearest water of any lake in Japan, Mashu is said to have underwater visibility exceeding 131 ft (40 m). To view the lake you must ascend to the crater's rim by car where there are three main viewing stations

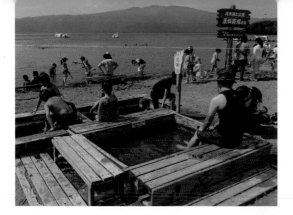

Left Hot-spring foot baths at Suna Yu on the sandy shores of Lake Kussharo.

Below Known to the Ainu as "A Mountain God's Lake," Kaminoko Pond is a small pond of crystal clear water with a mysterious source. Located just north of Lake Mashu, it is said the pond is somehow connected to the lake underground and fed like a spring from the bottom of the pond.

takes a longer, more gradual climb to a larger viewing site—**Lake Mashu Observatory 1** (2,240 ft/683 m), with toilet facilities, shops and a restaurant.

On Mashu's southern flank, the crater of the volcanic peak of **Mt Kamui** looks out over the lake and the tiny **Kamuishu Island** poking out from its center. The caldera's steep, forested sides rise 492 ft (150 m) above the water's surface and plunge to an almighty depth of 692 ft (211 m). The lake is often shrouded in fog and has been a source of mystery and legend since the time the indigenous Ainu inhabitited the area. Entering the lake itself is prohibited.

around the perimeter—two on the western side, and one on the east.

In summer months, approaching from Mt Io, there is a steep, winding road that climbs the eastern flank of the crater, ascending sharply via a series of switchbacks to the **Lake Mashu Observatory 3** (2,300 ft/701 m). In winter this road is closed and visitors must use a road to the south which

Kussharo's Lakeside Onsens

Born of ancient volcanoes, Lake Kussharo is a tranquil nature reserve but there are a few hidden secrets pointing back to a violent past.

Waters heated by subterranean volcanic activity push to the surface along the lake's edge, in several places creating makeshift natural onsen; some with rock edges capturing the heated water, others with simple timber structures built to provide some form of privacy for keen onsen-goers. There are a number of free, mixed-gender baths you can enter wearing bathing costumes.

Working your way from the Wakoto Peninsula along the eastern edge of the lake you will find **Wakoto Hot Spring**, **Kotan Onsen Hot Spring**, **Ikenoyu**, **Iso Yu**, and finally **Suna Yu**, where you can dig your own onsen bath in the sand. Water seeps through the sand on the edge of the lake where you can also dangle your feet in a footbath.

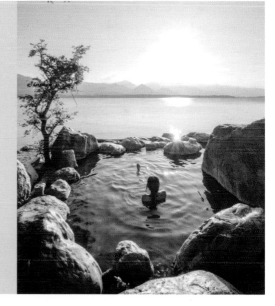

Abashiri & the North Coast: The Frozen Ocean

The northeastern coastline of Hokkaido stretches over 248 miles (400 km) with a few major towns dotted along the meandering road that runs from Wakkanai to Shari and the Shiretoko Peninsula. Probably the most significant of these is Abashiri, a business hub and small, humming city of around 40,000 people on the Sea of Okhotsk. The city is cold yet friendly in winter, and in summer its pulse rises to an energetic beat as the surrounding farms and fishing industries kick into full swing after a frozen winter.

Abashiri makes for a well-appointed base to explore this eastern area of Hokkaido, and is the primary gateway to witness the natural wonder of *ryuhyo*—drift ice—covering the Sea of Okhotsk.

Hokkaido's drift ice, born of freezing conditions in the Russian Arctic, comes from the Amur River, on the border between China and Russia. Fresh water from the river enters the Sea of Okhotsk, lowering the salt concentration and causing the water to freeze, forming drift ice. Through the months of January and February a magnificent expanse of white pancake ice pieces, collected together in a gently moving oceanic slushy, cover almost the entire Sea of Okhotsk, freezing the harbors and enveloping the northern coastline of Hokkaido.

Aurora Icebreaker cruiseboat tours run from Abashiri Sight Seeing Information Center, in the mouth of Abashiri River (5 minutes' drive, 1.2 miles/2 km from Abashiri Station), from around the middle of January to the beginning of April (¥3,300 for adults,

Above Special ice-breaking cruiseboats forge their way into the ice-covered Sea of Okhotsk offering visitors an up close view of this wonderful winter phenomenon.

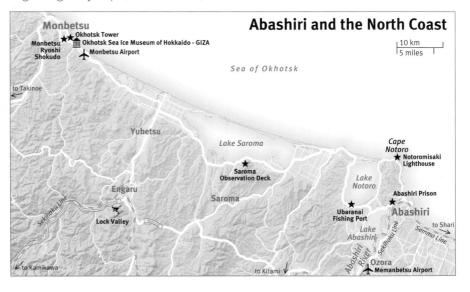

Abashiri and the North Coast

Above Fistful of fish! In winter months, when the harbors freeze over, the fishing focus turns to the lakes where smelt are caught through holes drilled in the ice.

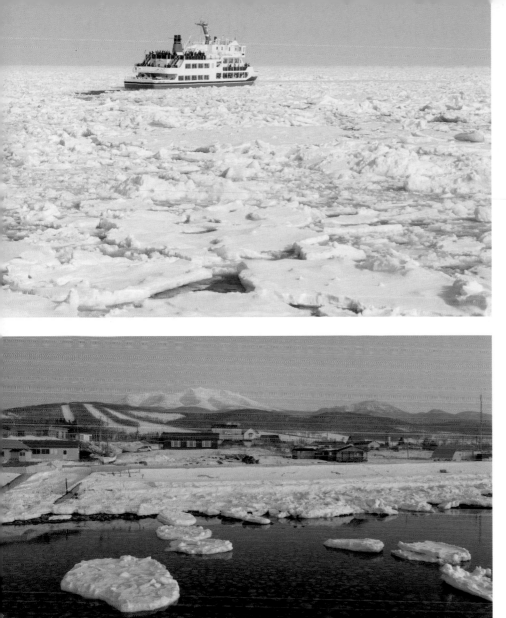

Above Looking back to the frozen shores of Shari with Unabetsu Ski Area and Mt Unabetsu in the distance.

¥1650 for students).

A 20-minute drive (7.5 miles/12 km) west from Abashiri city along the coast will lead you to **Cape Notoro**, where **Notoromisaki Lighthouse** stands 69 ft (21 m) tall on a 164-ft (50-m) high cliff-face, with walking trails leading around the headland. The cape is well known for beautiful scenery where the blue sky, green grass and emerald ocean meet, while in winter this view is replaced by a white horizon as the cape is wrapped in sea ice.

Lake Notoro will come into view a 10-minute (3.7 miles/6 km) drive further on from the cape where, in autumn months, you can see coral grass—a natural phenomenon where a special species of sea plant, growing in this saline lake, turns a deep red color. The lake's 10 acres (four hectares) of coral grass are in full bloom in

September when the contrasting colors between the blue lake and red corals creates a striking autumnal scene. The coral grass can be seen at Ubaranai fishing port on the southern end of the lake about 25 minutes' drive (12.4 miles/20 km) from Cape Notoro.

Lake Saroma is probably best seen from **Saroma Observation Deck**, which, if driving from Abashiri directly, is about 1.25 hours (35 miles/57 km). This is Hokkaido's largest lake by area and the third largest in Japan. The perimeter of the lake is about 54 miles (87 km), and the maximum depth is 64 ft (19.6 m). A thin sandbar, varying from 2,297 ft (700 m) to 656 ft (200 m) in width, prevents the lake from being absorbed into the Sea of Okhotsk. In winter the lake freezes over creating a white, ocean-side desert.

From Lake Saroma, **Monbetsu** is a further 1.25-hour drive (37 miles/ 60 km), another popular place from which to view the drift ice, and where

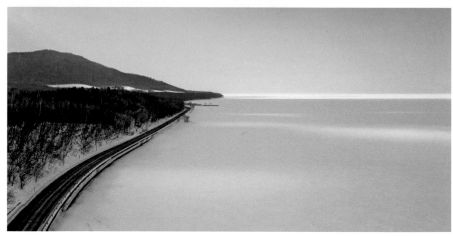

the **Garinko II** boat cruise embarks during the drift ice season (¥3,000 for adults, ¥1,500 for students). For land-based viewing there is **Okhotsk Tower**— the world's first underwater observation tower where you can experience the world beneath the drift ice, 23 ft (7 m) below the surface. The observation room at the top of the tower, 125 ft (38 m) above the ocean surface, has

360-degree views over the sea ice all the way to Shiretoko. Okhotsk Tower is located on the eastern side of Monbetsu Harbor and open 10 am–5 pm (adults ¥800, children ¥400).

Here you will also find the **Okhotsk Sea Ice Museum of Hokkaido GIZA**, a hands-on museum dedicated to drift ice and a frozen aquarium with fish, shellfish, seaweed and other oceanic

Ice Fishing on Lake Abashiri

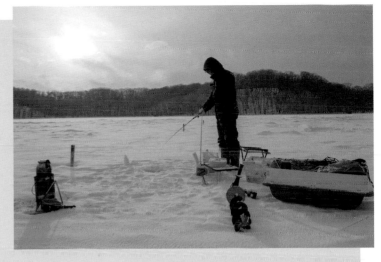

Surrounding Abashiri are several lakes which succumb to the icy white of winter and freeze over, creating beautiful and surreal landscapes and the perfect opportunity for ice fishing. Ice fishing tent villages spring up and bring a unique and beautiful landscape to life with color and activity. As the boats sit on the dry-side in the harbors, banished from the winter waters by the ice, the fishermen venture out onto the lake to drill holes in the ice and try to relieve the waters of their hidden stashes of fish.

Ice fishing involves boring a hole through the thick surface ice, done with a hand auger, or home-made, modified grass cutter for some fuel-powered assistance. This is usually covered by a tent, with a couple of seats, a warm thermos of hot coffee or soup, and a patient temperament to sit and wait for the fish to nibble.

A great place to go to spectate or participate in this winter activity is on the shore of Lake Abashiri, about a 0.2 mile (300 m) walk from the Abashiri Kanko Hotel or a seven-minute drive (3 miles/5 km) from Abashiri Station. Tours are available from the first week of January until the last week of March, take around two hours, include all of your equipment and even include cooking your catch of smelt fish—tempura style (adults ¥4,000, children age 6–12 ¥3,000).

Left Huddled over crudely drilled holes in the ice, fisherman play a game of patience and perseverance. Enduring the cold winter temperatures in little tents, they dangle their lines, waiting for a bite... but as a half-day activity, it's quite a lot of fun!

Top and above Freshly caught smelt at its best when taken straight from the lake and coated in a hot tempura batter. Many tours will offer to cook your catch there and then!

Abashiri Prison

Abashiri Prison was once the penitentiary stronghold for the most hardened criminals in Japan being dealt the harshest penalty (aside from execution) handed down from the nation's judges. The original prison was in operation from 1890 to 1984 but has now been moved and converted into a museum at its new site on the slopes of Mt Tento.

In 1890, the borders in East Asia were still not clearly defined. Japan claimed Hokkaido but the Meiji government was afraid that imperial Russia would march into the northern part of the island. Much like neighboring Siberia, it was sparsely inhabited with little more than a few fishing villages and vast expanses of forests populated by bears.

This land had to be quickly developed and connected to the settled parts of Hokkaido. Thus, in the spring of 1890, the first batch of prisoners was dispatched to the strategically-located fishing village of Abashiri. The prisoners came from all over Japan and their first task was to build a road connecting Abashiri to an already-developed outpost close to Asahikawa in Central Hokkaido.

The working conditions were extremely tough and everything had to be done by hand—the trees felled, the terrain cleared, the road constructed, and bridges built. Food was scarce and accidents very common, and to add to the challenge, every prisoner had a heavy iron ball chained to a foot to prevent them from disappearing into the wilderness. Working through the extreme cold of the Hokkaido winter, the road was finished in record time and Japan was able to claim the north east of Hokkaido, inadvertently turning these castaways of society into national heroes.

The preserved buildings of the original Abashiri Prison feature recreations of the lives of prisoners and guards, giving you a feel for what life here would have been like some 100 years ago.

Above Fishing boats sit on the frozen dry docks of Shari as winter claims the harbor.

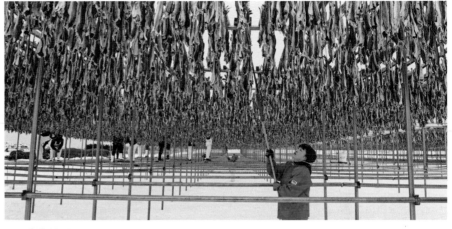

Above A woman tends to fish drying racks along the Shari harbor side.

specimens frozen in clear blocks of ice and arranged for visitors to view (9:30 am–5 pm, closed Mon, adults ¥450, students ¥150).

Monbetsu is also well known for all things crab. The quality of crab caught in the icy waters off this part of Japan is touted as the country's best. **Monbetsu Ryoshi Shokudo** is part-restaurant and part-cooking school where you can learn all the intricacies of how to best prepare a crab and get meat from the shell, there are also menu options available that don't require you to get your hands dirty (11 am–5 pm, closed Mon).

Should you choose to chase the sea ice east from Abashiri—recommended if you are visiting later in the season— you will head towards the small town of **Shari**, from where you will see the

beautiful Mt Shari rising 5,075 ft (1,547 m) from farmlands to the south. Shari is about 45 minutes' drive (25 miles/40 km) from Abashiri and its quaint harbor-front is a great place to see fish drying by traditional means, across a web of netted hanging fields.

Chasing the ice further will eventually bring you to **Utoro**, a 45-minute (23 miles/37 km) drive from Shari. Here you can take walking tours onto the ice providing an insight into

Right Sunset over the harbor of the remote town of Utoro, the last notable civilization on the far north-east coast of Hokkaido.

how some of the earliest people may have arrived in Hokkaido from the lands to the north. Suited up in a dry suit you can also opt for a dip in the frozen ocean, if you're brave enough. Tours cost around ¥5,000 and last 90 minutes.

Cape Puyuni, on the road leading out of town, provides a great spot for watching the sunset over the ice. In winter the road terminates just beyond here, near the Shiretoko Nature Center.

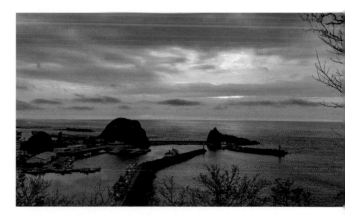

The Shiretoko Peninsula:
A UNESCO World Heritage Site

There is nothing else in Hokkaido quite like Shiretoko—a true natural wonder and a recognized UNESCO World Heritage Site. Protruding from Hokkaido's east like a giant finger, pointing out across the ocean to the wild lands of the arctic north, and along the dividing line between the Sea of Okhotsk and the Pacific Ocean, the Shiretoko Peninsula is the most remote corner of the entire Japanese archipelago. It is truly the final stronghold of Japan's wild animals and a fortress of impenetrable mountains and forest resisting the push of humanity, remaining utterly pristine.

Home to the Hokkaido bear, Ezo deer and some of the rarest birds on the planet, **Shiretoko** is the domain of the animals. Human habitation is limited to coastal fishing villages clinging to the edges of the peninsula as far as road access can reach. Beyond here the peninsula continues eastward as a natural wilderness of mountains and forest.

The Shiretoko Peninsula, with **Cape Shiretoko** at its tip, is the epicenter of a powerful seasonal food chain driven by the nutrient-rich oceans and winter's annual reset of sea ice. The cold oceans power the ecosystem which brings marine life of all sizes including various whale species. In spring, pods of orca can be seen hunting in these waters, while summer brings 15 m sperm whales.

Along the center of the peninsula is the **Shiretoko Mountain Range**, a vast swathe of densely forested and inaccessible mountainous terrain. Mt Shiretoko heads the range closest to the tip of the peninsula in the north, with Mt

View looking back over the timber walkways of the Shiretoko Five Lakes towards Mt Rausu and the Shiretoko Mountain Range.

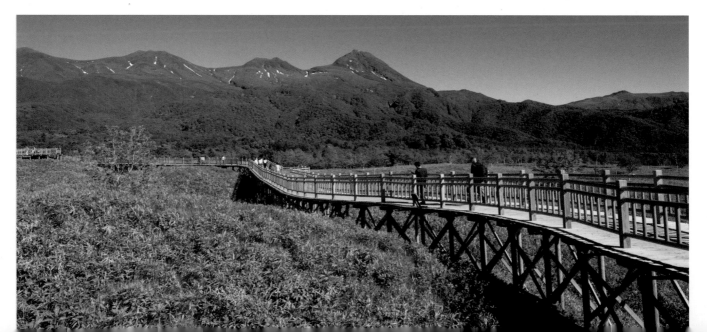

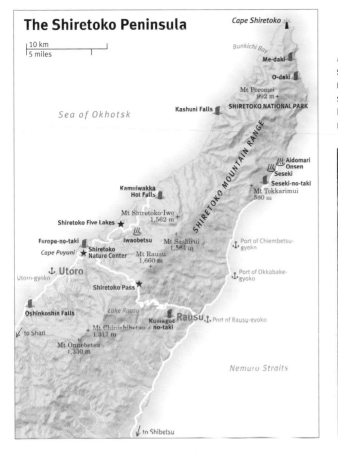

The Shiretoko Peninsula

10 km
5 miles

Cape Shiretoko

Bunkichi Bay

Me-daki

O-daki

Mt Poromoi
992 m+

Kashuni Falls

SHIRETOKO NATIONAL PARK

Sea of Okhotsk

SHIRETOKO MOUNTAIN RANGE

Aidomari
Onsen
Seseki
Seseki-no-taki
Mt Tokkarimui
560 m

Kamuiwakka
Hot Falls

Mt Shiretoko-Iwo
1,562 m

Shiretoko Five Lakes ★

Iwaobetsu

Mt Sashirui
1,564 m

Port of Chiembetsu-
gyokn

Furepe-no-taki

Cape Puyuni ★ Shiretoko
Nature Center

Mt Rausu
1,660 m

Port of Okkabake-
gyoko

↓ **Utoro**

Utoro-gynkn

Shiretoko Pass ★

Lake Rausu

Rausu ↓ Port of Rausu-gyoko

Oshinkoshin Falls

Mt Chinishibetsu
1,317 m

Kumagoe
no-taki

↓ to Shari

Mt Onnebetsu
1,330 m

Nemuro Straits

↓ to Shibetsu

Below Oshinkoshin Falls is a spectacular waterfall nicknamed Sobi no Taki (twin beauties waterfall) as the stream is split into two separate falls. It is located just next to the coastal road running from Shari to Utoro.

Bottom Aerial view of the walkways traversing the marshlands to the first of the Shiretoko Five Lakes.

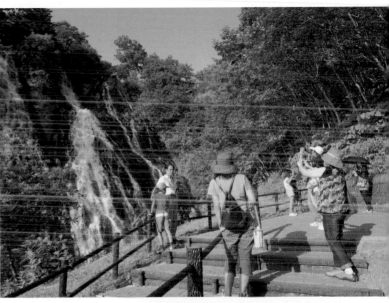

Shiretoko-Iwo, Mt Rausu, Mt Onnebetsu, and Mt Unabetsu to the south.

Approaching Shiretoko along the northern side of the peninsula, you will pass through Shari before driving along the water's edge to Utoro. About 10 minutes from Utoro (4.3 miles/7 km) is **Oshinkoshin Falls**, right by the roadside. A beautiful, fan-shaped waterfall, divided in two by a tree-covered rock, the waterfall is like a large curtain, marking the entrance to Shiretoko. From Utoro there are options to take boat trips further along the coast where several waterfalls meet the ocean, **Kashuni Falls** of particular note. The view from the water back to the coastline is reminiscent of a Jurassic world with twisting, jagged cliff faces guarding the wilderness above. It is very common to see groups of bears on the rocky beaches and hunting in river mouths.

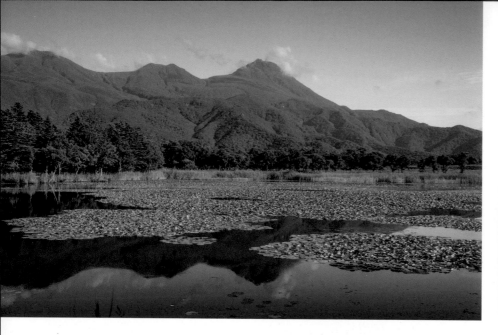

Above The peak of Mt Rausu reflecting in the still waters of one of the Shiretoko Five Lakes.

Below The cascading warm waters of Kamuiwakka Hot Falls collect in ponds as they flow down the mountain from their volcanic source. A fun barefoot adventure!

Above The rustic structure of the Aidomari Onsen, set on a stony beach overlooking the sea towards Kunashiri Island.

From Oshinkoshin Falls the road leads up into the mountains (17 minutes' drive, 7.5 miles/12 km) to the **Shiretoko Nature Center** (9 am–4 pm [8 am–5:30 pm late-Apr to late-Oct], free), a good place to stop to collect information on the national park. From here, heading into the park are the **Shiretoko Five Lakes** with some short, easily accessible boardwalks that give visitors the option to take in the beauty and unique bio–diversity of the area without disturbing any of the natural habitat. On a still day the lakes offer spectacular reflec-tions of the vast mountains rising in the distance. Continuing on this road a further 15 minutes (6.2 miles/10 km) will bring you to **Kamuiwakka Hot Falls**,

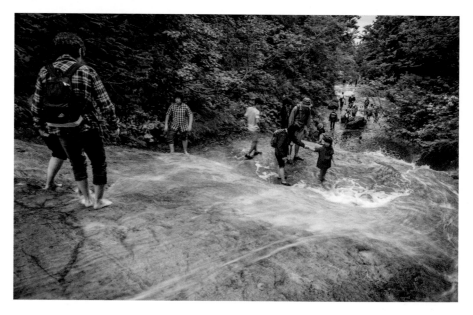

Above Kashuni Falls is one of many cliffside waterfalls that cascade directly into the sea from the Shiretoko Peninsula. Difficult to access from land, boat tours are the best way to capture a glimpse of these rare waterfalls.

a wide-flowing creek of hot onsen water slithering its way down the rock face where you can walk barefoot through the warm waters.

Beyond the Shiretoko Nature Center the road climbs into the mountains, heading south to cross the peninsula over the **Shiretoko Pass**. The 17 mile (27 km) road carves a serpent-like course across the mountains—with spectacular views to Shiretoko's highest peak Mt Rausu

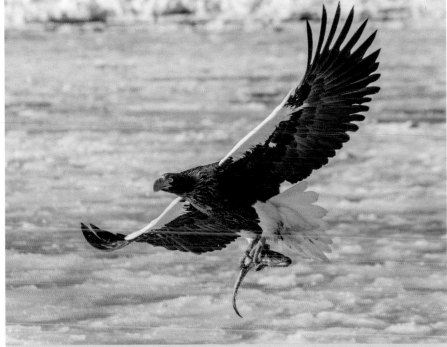

The Owashi Eagle: The World's Largest Raptor

Spending time in Eastern Hokkaido, you're almost guaranteed to encounter the world's largest raptor—the *owashi* (Steller's sea eagle). Known for their distinctive yellow beaks, these birds can weigh up to 20 lb (9 kg) with wing spans reaching up to 8 ft (2.5 m).

Each winter, many *owashi* eagles migrate from their northern breeding grounds in Far Eastern Russia and the Kamchatka Peninsula to Japan—and primarily Eastern Hokkaido. With their migratory population linked to the fertile waters of the Sea of Okhotsk and the annual sea ice, about 5,000 individual birds call this lush pocket of the world home.

Hokkaido Bears

The Hokkaido brown bear (*higuma*) is the undisputed apex predator of the island. Referred to as "the gods of the mountains" by the indigenous Ainu, they are larger than the black bears that are found on Honshu (Japan's main island) and more southern parts of Asia and share an ancient migratory history with their black grizzly cousins in North America.

Hokkaido is home to an estimated 3,000 bears, with their numbers concentrated in the wildest parts of the island, in particular Shiretoko, where they are most prolific. Mostly vegetarian, these beautiful creatures can exceed 772 lb (350 kg), crowning them kings of the wilderness. They are shy but dangerous in the wild, particularly if disturbed—a testament to which is the constant chime of bear bells from the backpack of almost every hiker you pass on mountain trails.

Bunkering down in dens through winter, the bears rise with the call of spring and spend their summers in the lush forests and woodlands with food in abundance. Rivers bring fish and the vast mountains provide food and refuge where the press of humanity is least felt. What better place to be a god than the wild forests and mountains of Hokkaido.

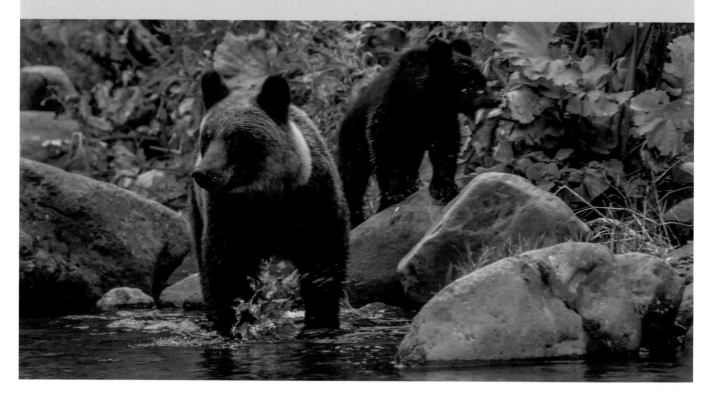

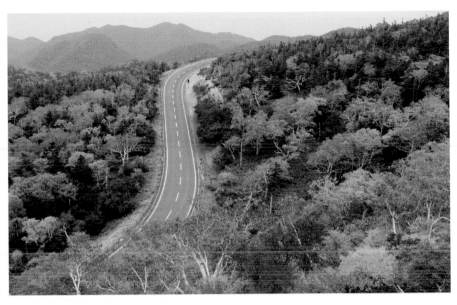

Above Hokkaido deer are known to be one of the largest of the sika species and to also have the largest antlers. Stags can exceed 441 lb (200 kg) with their antlers growing over 3.3 ft (1 m) long.

(5,449 ft/1,661 m)—and descends to the town of Rausu on the southern side. In autumn this drive offers a complete immersion in color as the forest slips into its brightly colored jacket before the winter strips the trees of their leaves and pushes Shiretoko into hibernation.

With ocean on one side and a high, bear-proof fence on the other, the road from Rausu along the southern coastline of the peninsula is a small strip of land with houses and fishing boats dotted sporadically along its length. Nearing the end of this road, 15.5 miles/25 km (30-minutes' drive) from the center of

Top The meandering high mountain pass cutting through the autumn forests of the Shiretoko Peninsula.

Above Blakiston's fish owl is the largest living species of owl. They can reach up to 10 lb (4.6 kg), stand almost 27 in (70 cm) tall and have a wing span of almost 6.5 ft (2 m). They are endangered and extremely rare with fewer than 150 birds living in Japan.

Rausu, is **Aidomari Onsen**, a beachside onsen dug into the stony shore. With a constant flow of hot water, it is in stark contrast to the frigid ocean just a couple of meters away. The onsen itself is rustic and homemade, managed by the volunteer efforts of local residents, with tarpaulins and temporary timber framing separating the men's and women's baths. A soak in this ramshackle structure with the ocean lapping the shoreline is a once-in-a-lifetime experience. Depending on the season you'll find this onsen about 30 minutes' drive (18.6 miles/30 km) from Rausu.

Shiretoko is also home to one of the rarest and largest owls on earth—the Blakiston's fish owl. These can be spotted within the national park and almost nowhere else on earth.

Helpful Tips for Planning Your Visit and Getting Around Hokkaido

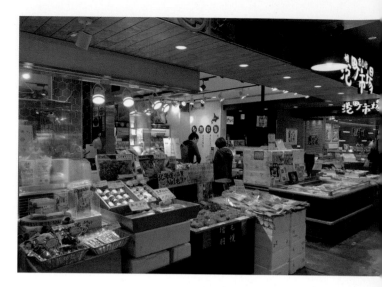

New Chitose Airport has a great selection of shops offering specialize Hokkaido products. It is a perfect place to pick up gifts and souvenirs!

GETTING TO HOKKAIDO

Opened in 1991 and renovated in 2011, New Chitose Airport (CTS) is 25 miles (40 km) southeast of Sapporo and serves both domestic and international flights. It is Japan's fifth-busiest airport in terms of passengers carried, and the Sapporo-Tokyo Haneda route is the third busiest airline route in the world. Some 20 million people make their way through the airport's semicircular terminal each year and there is a large shopping and restaurant area to cater for them. Divided into amusingly-named, themed sections such as "Smile Road," "Sweets Alley" and "Ramen Street," there are plenty of dining options and—unlike most airports' food offerings—the food is actually very good.

New Chitose is connected to JR Hokkaido's Chitose Line and trains run to and from Sapporo Station, take 35–40 minutes and cost ¥1,070, or ¥1,590 if you'd like to reserve a seat. The airport is also serviced by a fleet of airport buses running regular services to Sapporo and several ski resorts and onsen towns. If you're planning to rent a car, you'll need to take the courtesy bus to the airport's dozen or so car rental depots. There is an infor-mation counter on the first floor of the international terminal and, depending on the car and the season, you can expect to pay somewhere between ¥6,000 and ¥10,000 per day on top of fuel costs. There are also taxi stands located on the ground floors of both the domestic and international terminals, and you can expect to pay around ¥10,000 to get to downtown Sapporo.

If your phone is unlocked, you can buy a local SIM card from the Docomo counter in the international arrivals lobby, or from a So-Net vending machine (both approximately ¥5,000 for seven days of unlimited data). There is also the option to pick up a portable WiFi device, with mobile centers in both terminals. Expect

HOKKAIDO FACTS AT A GLANCE

Area: 32,222 square miles (83,454 square km)—approximately 22% of Japan's total landmass and roughly the size of Maine or Scotland **Location:** 41° 21' - 45° 33' north (latitude)—similar to the American Great Lakes region or Switzerland
Highest point: Asahidake: 7,513 ft (2,290 m) **Length of coastline:** 27,696 miles (44,573 km)
Population: 5,285,430 (2019) **Population density:** 67 per 0.4 sq mile (1 sq km)
Percentage of land that is forested: 71% **GDP:** ¥18.9 trillion = US$172 billion
Number of Shinto shrines: 799 **Number of Buddhist temples:** 2,330
Number of convenience stores: 2,971 **Tourism mascot:** Kyun Chan, a northern pika (Japanese guinea pig) in a deer costume

to pay around ¥750-¥850 per day, excluding insurance (and it can be cheaper if you pre-book before you arrive).

The Hokkaido Shinkansen (bullet train) opened in 2016, making it possible to get from Tokyo to Hakodate in as little as four hours. The train terminates at Shin-Hakodate-Hokuto Station and from there you'll need to take the local Hakodate Liner to reach Hakodate Station in the center of the city. The Shinkansen runs 10 round trips per day and a one-way reserved seat costs around ¥23,000. If you're planning on train travel during the rest of your trip, a JR Rail Pass could be a good investment as the Hokkaido Shinkansen is included in the price. An unlimited seven day JR Pass is around ¥30,000 for adults and ¥15,000 for children.

From Hakodate Station you can take a local train (Hokuto Limited Express) which stops at several stations on it's 3.5hr journey north to Sapporo. Close by the station are several car rental services. Prices start at around ¥10,000 per day.

The cheapest—but slowest—way to get from Honshu to Hokkaido is by ferry, with terminals located in Tomakomai, Otaru and Hakodate. Tomakomai has two terminals and is linked to the most cities, but ferries can be infrequent and the journeys long (11 to 32 hours). A couple of shorter hauls from Oma and Aomori, in Honshu's north, will get you to Hakodate in two and four hours respectively and cost ¥2,000.

GETTING AROUND

The best way to explore Hokkaido is by car. Sure there are plenty of tourist buses, train options, and myriad day-trips that will get you to the most popular tourist spots, but if you long to experience the true Hokkaido then you need to get lost.

Driving around the islands is easy if you have the patience. Traffic moves smoothly but slowly, so prepare yourself for long days in the car if you hope to traverse the main island in a day or so. A better method is driving short days, breaking up trips into destinations only a hundred miles or so apart. While you can certainly join the dots and jump from point to point across Hokkaido, some of the most enriching experiences are the surprises you find on dead-end streets and wrong turns you take along the way.

Hokkaido has excellent roads with English signage and convenient *michi-noeki*, or roadside stations, generally open 24-hours and selling snacks, local produce and souvenirs. Outside of Sapporo, parking is free in most places and petrol stations embody the philosophy of *omotenashi*, or good service, making you feel like an F1 driver in a pit stop. Many stations will close around 7 pm, maybe earlier in the smaller towns, and are closed on Sunday, so be sure to refuel regularly, and early. You'll need to have your passport with you at all times, along with an International Driving Permit, as issued

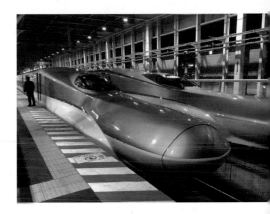

The Hayabusa or "Peregrine falcon" is a high speed Shinkansen service running between Tokyo and Hakodate since 2016.

by your local automobile association.

Hokkaido's wealth of wildlife is one of its drawcards but it can also be an unexpected road hazard, particularly in the less populated regions and when visibility is low. So be wary of deer in particular and, if you're lucky enough to come across one, the legendary *tanuki*, or Japanese racoon dog.

Limited-express trains connect the major cities across Hokkaido and are covered by the country-wide JR Rail Pass, or if you're not planning to leave the islands, a Hokkaido Rail Pass will get you seven days of unlimited travel for ¥24,000 or ¥12,000 for children. The Hokkaido Rail Pass will also cover some JR Bus Routes, including an express bus between Sapporo and Otaru. Not covered by the Rail Pass but with extensive coverage of the main island, the Hokkaido Chuo Bus Company connects

Sapporo to most other major cities with frequent express buses. It also runs day and night tours to all the big Central Hokkaido sightseeing spots.

New Chitose and Sapporo's Okadama Airport are connected to other major Hokkaido cities, such as Hakodate, Kushiro and Wakkanai, and most destinations are a one-hour flight away. It's not the cheapest way to travel and flights are limited but Japan Airlines and All Nippon Airlines will get you there quickly if you're working with a limited time frame.

Sapporo's flat grid is great for cycling and the city's bike-share program, Porocle, allows you to borrow and return bicycles at any of the 40 or so ports within the city center. Operating from May to mid-November, this is a good option to connect the dots on a day of sightseeing. If you have a mobile number and a passport, you can register inside train stations and some convenience stores and a one-day pass will set you back ¥1,500.

For more experienced pedal-power enthusiasts Hokkaido's wide-open, well-maintained roads and stunning backdrops have made it something of a Mecca for cycle tourists wanting to get off the beaten track. The Cycle Tourism Hokkaido Promotion Network was established by 44 companies and organizations and provides a free online guide to 20 courses across eight regions, along with a wealth of information on gear, storage, rest stops, and road rules.

NATIONAL PARKS

Akan-Mashu is one of Japan's oldest national parks, established in 1934. It covers 349 mile2 (904.81 km^2) and is home to crystal-clear crater lakes—Akan, Mashu and Kussharo—the world's largest marimo (moss balls), boiling mud and hot springs.

Daisetsuzan was also established in 1934 and is Japan's biggest national park, at a whopping 876 mile2 (2,267.64 km^2). In the center of the main island, this is a region of primeval forests and big peaks, including Hokkaido's highest, Asahidake, at 7,513 ft (2,290 m).

Kushiro-Shitsugen, south of Akan-Mashu, is a large (104 mile2/268.61 km^2) wetland ecosystem that is home to over 600 species of plants and the endangered red-crested crane.

Rishiri-Rebun-Sarobetsu is the northernmost national park, with remote islands and myriad land-scapes—mountains, marshlands, alpine flora, sea cliffs, wetlands, and coastal sand dunes.

Shikotsu-Toya is a nearly 386 mile2 (1,000 km^2) swathe of caldera lakes and active volcanoes in Southwest Hokkaido, stretching from Lake Shikotsu to Lake Toya, and Mt Yotei to steaming Noboribetsu. Its proximity to Sapporo and New Chitose Airport makes it easy to access and enjoy.

Shiretoko National Park's name is derived from the Ainu word "siretok", meaning "the end of the earth" and this UNESCO World Heritage Site is one of the most remote regions of Japan. Its rich ecosystems and dramatic land-scapes are home to diverse wildlife, including brown bears and killer whales.

The Hokkaido red fox is perhaps Hokkaido's most familiar creature. Clever, curious and showing little fear of humans, they are distinctly recognizable for their lustrous coats, particularly in contrast to the white snowscapes in winter.

Photo Credits

All photos copyright Aaron Jameison, except following:
Front cover bottom middle, p 28 © Darren Teasdale; **p3 top right, 89, 95 top, 98 bottom** © Nagi Yoshida; **p13 right, 29 top, 56 top left** © Alister Buckingham; **p23 top right, 33 middle right, below, 54 bottom, 91 top, 92/3 top middle, 97 left top, right bottom** © Neil Hartmann; **p33 top** © SKYDIVE HOKKAIDO; **p44 bottom** © Chopsticks On The Loose; **p53 top, 57 top, bottom left and right** © David Middleton; **p53 middle** © Nolan Isozaki; **p76, 96 bottom** © Sofia Llamas; **p97 left bottom, 99 bottom** © Jimmie Okayama; **p100 bottom** © Toshi Pander; **p108 top, bottom, right** © Mike Richards; **p117 top** © Christopher Webb
Stock photo credits
123rf.com—**Front cover** Ondrej Prosicky; **back cover, p39** Thirawatana Phaisairatana; **p91** azeitler; **p110** SAN HOYANO.
Dreamstime.com—**Front flap** Bennnn, **back cover, p2** Nuvisage; **p7** Knotmirai; **p69** Sean Pavone; **p73** Outcast85; **p91** Andreas Zeitler; **p92** Konstantin Shadrin; **p105** Spiridon Sleptsov; **p109** Kaedeenari; **p112** Tristan Scholze.
istockphoto.com—**Front cover** kata716; **front endpapers, p54/55, 59** thanyarat07; **p39** MasaoTaira; **p56** DavorLovincic; **p67, 79** gyro; **p90** GA161076; **p92, 106, 114** azuki25; **p113** ANDREYGUDKOV.
PIXTA—**Back cover** 40944056 T2; **p21** north4nature; **p77** takanotume; **p78, 83** Satoru Kobayashi; **p78** 29575006.
Shutterstock.com—**Front cover** Ohishiapply, Supermaw, tkyszk; **front cover, p53** Aeypix, front cover; **back cover, p19** Pommy.Anyani; **back cover, P104/5** atthle; **back endpapers, p68** dmnapat; **p2** Club-4traveler, Prawat Thananithaporn; **p3** littlewormy; **p4** K Thitipong; **13** Brian Lam; **p10** Michael Tanu-jaya; **p11** MH-Lee; **p12** Johnathan21, Nishihama; **p14** icosha; **p14, 15, 16, 23, 26, 37** Sean Pavone; **p16** BonStock, Blanscape; **p17** KP Suwannasuk, THONGCHAI.S; **p19, 20** tasch; **p20** MEARFENA TRAYRER; **p22** NewSaetiew; **p25** Koki Yamada; **p27** Bankoo, C.Lotongkum; **p30** Abbie0709, Lifestyle Travel Photo; **p31** note2photo, ThavornC; **p32** NOOR RADYA BINTI MD RADZI; **p32, 83** tkyszk, **p36** Korkusung; **p38** Chutima Chaochaiy; **p41** Akane Sakata, TY Lim; **p52** Ong.thanaong; **p55** SUJITRA CHAOWDEE; **p62** Nussar; **p69** Yullana Jaowattana; **p70** CHEN MIN CHUN, stock_shot; **p6, 72** Vassamon Anansuk-kasem, Chatchai Kaigate; **p74** Kit Leong; **p75** littlewormy; **p79** hama1080; **p80** osap; **p80, 85** tsuchi; **p81** Naomichi Maki; **p82** PangJee_S; **p85** myfavoritescene; **p86** Gold33; **p93** Various Images, Atosan; **p94** Nita Limo, kimonofish; **p95, 96** Tanya Jones; **p98** ayu1125; **p99** Anan Khusonsang; **p103** rayints, rolling rock; **p107** so51hk; **p111** EarthScape ImageGraphy; **p113** okimo; **p115** Ondrej Prosicky; **p116** retirementbonus

Acknowledgments

My deepest thanks to everyone who contributed to this book along the journey. The many miles traveled and stories shared with friends across the island created the DNA for this book.

My eternal gratitude to Kat Mulheran, Beau Taylor, Kris Lund, Sandra and Robert Jamieson (Mum & Dad), Acme Wu and Bob—Nothing is possible without you.

Published by Tuttle Publishing, an imprint of Periplus Editions (HK) Ltd

www.tuttlepublishing.com

Copyright © 2022 Periplus Editions (HK) Ltd

ISBN 978-4-8053-1400-5

Distributed by
North America, Latin America & Europe
Tuttle Publishing
364 Innovation Drive
North Clarendon, VT 05759-9436 U.S.A.
Tel: 1 (802) 773-8930
Fax: 1 (802) 773-6993
info@tuttlepublishing.com
www.tuttlepublishing.com

Japan
Tuttle Publishing
Yaekari Building 3rd Floor
5-4-12 Osaki
Shinagawa-ku
Tokyo 141-0032
Tel: (81) 3 5437-0171
Fax: (81) 3 5437-0755
sales@tuttle.co.jp
www.tuttle.co.jp

Asia Pacific
Berkeley Books Pte. Ltd.
3 Kallang Sector, #04-01
Singapore 349278
Tel: (65) 67412178
Fax: (65) 67412179
inquiries@periplus.com.sg
www.tuttlepublishing.com

25 24 23 22 10 9 8 7 6 5 4 3 2 1

Printed in China 2206EP

"Books to Span the East and West"

Tuttle Publishing was founded in 1832 in the small New England town of Rutland, Vermont [USA]. Our core values remain as strong today as they were then—to publish best-in-class books which bring people together one page at a time. In 1948, we established a publishing office in Japan—and Tuttle is now a leader in publishing English-language books about the arts, languages and cultures of Asia. The world has become a much smaller place today and Asia's economic and cultural influence has grown. Yet the need for meaningful dialogue and information about this diverse region has never been greater. Over the past seven decades, Tuttle has published thousands of books on subjects ranging from martial arts and paper crafts to language learning and literature—and our talented authors, illustrators, designers and photographers have won many prestigious awards. We welcome you to explore the wealth of information available on Asia at **www.tuttlepublishing.com.**

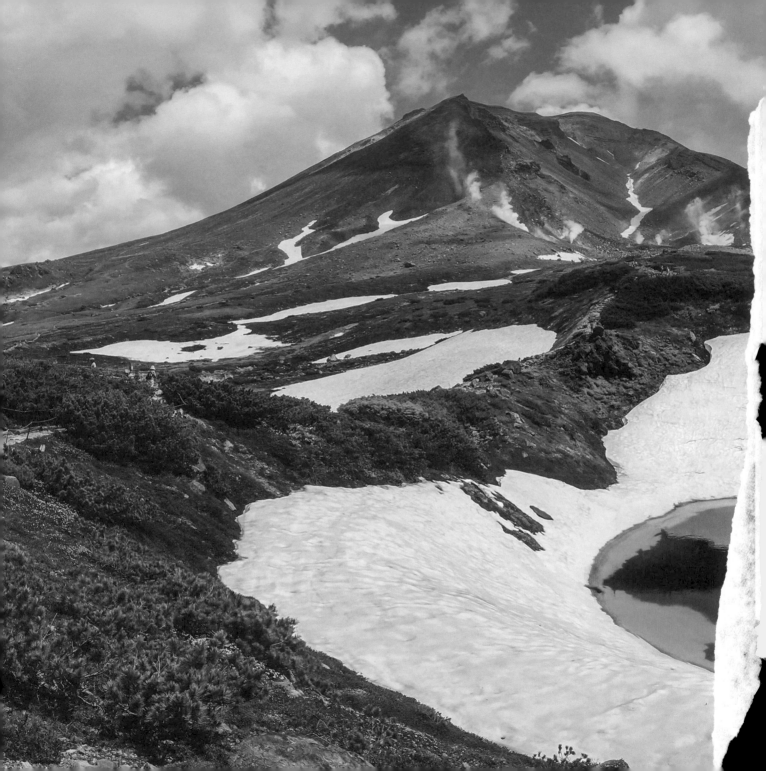